Relief Printmaking

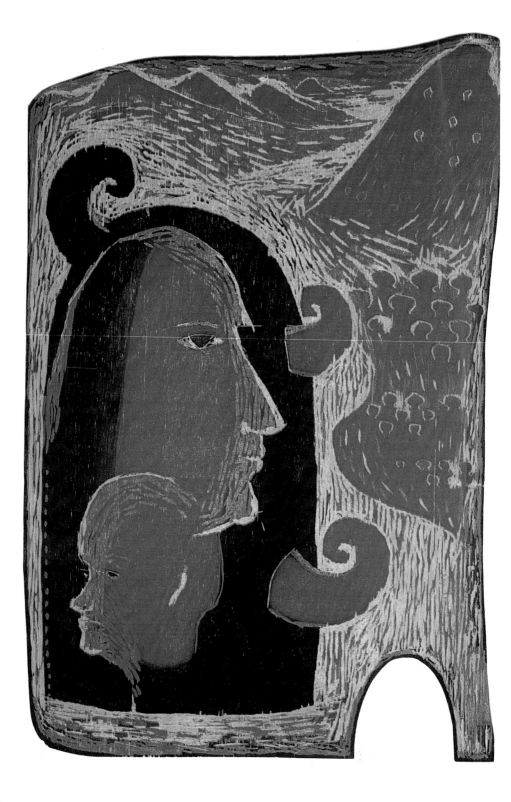

Relief Printmaking

ANN WESTLEY

A & C BLACK • LONDON

First published in Great Britain 2001

A&C Black Publishers Ltd
37 Soho Square, London, W1D 3QZ
www.acblack.com

Reprinted in 2004

Copyright © 2001 Ann Westley

ISBN 0-7136-7255-2

A CIP catalogue record for this book is available from the British Library.

Ann Westley has asserted her right under the Copyright, Design and Patents Act, 1988, to be identified as the author of this work.

Front cover illustration: *Lotus Love* by Ann Westley, 2001. Multiple colour woodcut, 56 x 37 cm.
Back cover illustration, top: *Path to the Unknown* by Kanchan Chander. Reduction woodcut from 3 mm (1$\frac{1}{2}$ in.) ply. 96 cm (37 $\frac{3}{4}$ in. x 24 in.) and bottom: *Babel/Vesuvius*, by Anne Desmet, 2002. Linocut wood engraving, flexograph print and collage on paper, 86.3 x 78.7 cm.
Frontispiece: *Path to the Unknown* by Kanchan Chander.

Designed by Janet Jamieson.

Cover design by Sutchinda Thompson.

Printed and bound in Malaysia by Times Offset (M) Sdn Bhd .

A&C Black uses paper produced with elemental chlorine-free pulp, harvested from managed sustainable sources.

CONTENTS

This book is dedicated to the memory of Shiko Munakata and Michael Rothenstein and to all printmakers from East to West who seek the spirit in the wood.

We have cast our earth in metal
to weave a solid weld around her throat
a band lace on her body's source.

Drop the fire brand which melts the ore
and watch as nature's form does rise
on gossamer she lights her phantom fall.

In life's craft I hear her voice
Mystery is art's undertaking
to know the properties of the earth
and reveal her work in silken wood.

No hard edge can sear this cloth about me spread.

'4WORD', letterpress wooden type.

ACKNOWLEDGEMENTS

I would like to thank all the artists who have generously provided images and information about their work. My special thanks to Sasha Grishin and Theo Tremblay for putting me in touch with many Australian artists, to Sophie Elson for her supporting research on artists' books, to Tessa Sidey, Keeper of Prints at the Birmingham City Museums and Art Gallery, to Peter Ford for introducing me to Polish artists, to Richard Anderton, Professor David Bethel, Richard Black, Sue Anne Bottomley, Ann Brunskill, Ken Campbell, Marcus Campbell, Julia Farrer, Professor Joel Feldman, Akiko Fujikawa, Walter Hoyle, Belinda King, Robert Kipness, Ian Mortimer, Sue Murray ARPS, Julian Rothenstein, Bob Saich, Agatha Sorel, Eric B. Vontillius, Brian West of Business Services, Suffolk, Barry Woodcock, and David Barker, senior lecturer of printmaking at Belfast University for guidance in my research on Chinese dab printing. Finally, my grateful thanks to Rosemary Simmons for her advice on this book.

AW

'Night Creatures in Ramingining' by David Malangi, Aus. Reductive linocut, 62 cm x 49 cm (24½ in. x 19¾ in.) ed. 90, 1998. Printed by Theo Tremblay.
Although David Malangi had retired, he agreed to do this one last work. David painted the full-colour design straight onto the lino in acrylic, refusing to work in other 'difficult media'. When I held up this print to show my students on one cold February morning, a huge bee flew into the studio, banged against the print and flew out again. 'And there goes the spirit of the artist,' I said.

INTRODUCTION

■ This book is written for the advanced student and the professional practitioner of relief printmaking. It is a technical book which contains personal descriptions of individual working processes accompanied by examples of prints sent to me from printmakers around the globe. When I wrote to each printmaker I requested technical information and a brief description of the ideas and concepts which inspired their work. Emerging from these essential sources are the innovations and imaginative leaps which determine the future evolution of this medium. The descriptions I received, many of which are related here in the artists' own words, illuminate the guiding force behind each technique and the reasoning for its use.

Relief printmaking is the most ancient and enduring of all print media. It is imbued with a history of many images from the past whose essence I have attempted to convey beneath the contemporary vision. In the course of writing about today's processes I travelled back along the old Silk Road and began to see a circular trail with no beginning nor end. Our working methods of today are the upper surface textures of an ancient, invisible fabric beneath which interweave a multitude of processes from East to West. The Silk Road is the backbone of my book.

The book shows too how today's relief print combines with other print media and has extended into painting, photography and the three-dimensional arena of sculpture and installation work; how the classic use of wood and metal type thrives alongside the found object and collage material; and how the rubber stamp and computer mouse are held with equal alacrity at the fingertips of the artist's book.

My research began in the summer of 1997 when I walked into a London exhibition of prints and sculptures by the Iraqi–German artist, Rashad Salim. Rashad's two- and three-dimensional works subtly convey the mysteries of deep layers of thought which their simple execution so carefully conceals. The duality of his vision and creativity carry the true essence of the art of the relief print which the best of visionary printmakers perceive – from the indigenous Australian artist who expresses his dreamings through the surface stuff of earth to the late English printmaker, Michael Rothenstein, who recognised that with each given cut we lever up the true nature of life which lies beneath the camouflage of everyday experience.

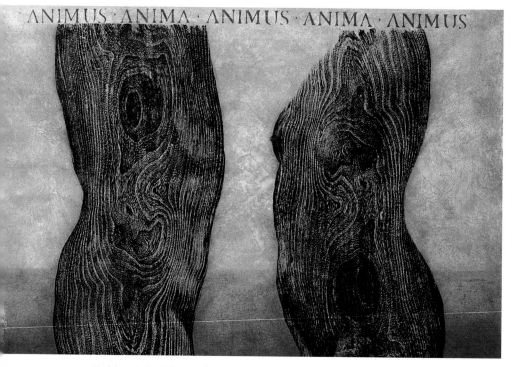

ANIMUS · ANIMA · ANIMUS · ANIMA · ANIMUS

'Animus Anima' by Maxine Relton, UK. A multicoloured woodcut with stencilled lettering on hand-made Japanese paper, hand-burnished with a metal spoon. 86 cm x 61 cm (34 in. x 24 in.) ed. 500, 1999.

The male and female figures are both taken from the same surface of an elm plank, inverted to give two distinct profiles. Maxine applies oil-based ink with a roller after minor alteration of the block's contours by masking; she then wipes the ink from the block with a rag to suggest the highlighted forms of the bodies and applies darker ink in the shadowed recesses while the ink is still wet. The background is printed in three stages from separate textured surfaces. Maxine started work on this print just after the loss of a long relationship and an operation to remove a tumour near her womb. In working the block, she discoverd a knot of wood located in the same area of the female form. When the inverted block is printed, this symbolic womb reappears in the heart of the man. After an illness of forty years, Michael Rothenstein also projected his new life's energy into printmaking from the twisting force of elm planks. As an introductory print, *'Animus Anima'* presents a metaphor for the balance needed to perfect our craft.

Rashad Salim's cross-cultural background has inspired an individualistic approach. His work represents a major shift of thinking and activity today. Like many artists, he is released from the constraints of a single tradition by living and working in several countries. Hence, he has acquired a rich visual vocabulary yet employs the simplest of processes and materials. The latter consist of fragments of found objects, the detritus of litter and discarded waste products of urban society. 'The streets of cities are full of rubbish – I never have to buy any of my materials,'

he laughs with glee. Rashad utilises what others discard and by keeping his resources and printing methods to an economical premium, he is a sensitive conservator and protector of the natural environment. His prints, which reflect this growing sense of responsibility amongst artists, are founded on a clear inner perception which cuts through the raw light of everyday experience to inform us of a deeper current of reality below the surface.

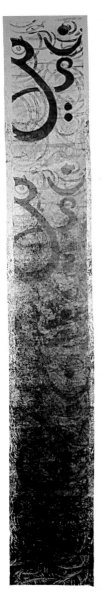

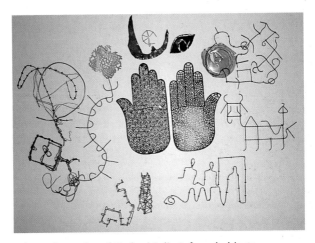

Above: Examples of Rashad Salim's found objects.

Left: 'Om Tonalities' by Rashad Salim, UK/Iraq.
One of a set of offset monotypes, 66 cm x 8.5 cm
(26 in. x 3³/₁₀ in.), 1998.
Rashad picks up information on the inked roller from a series of objects and calligraphic cut forms offsetting the loaded imagery directly onto the paper. 'I use various densities of rubber rollers to build up a layering of images in one print. Cylinder seals are a root technique that inspires my working method.' Rashad combines ancient and contemporary processes to make unfolding images of Islamic calligraphy and legends of Sumeria and Mesopotamia.

*'Horseshoe Pass'
by Emma
Stibbon, UK.
Woodcut using
two birch-faced
ply blocks, hand
burnished.
125 cm x 130 cm
(50 in. x 51 in.)
ed. 35, 1997.*

'Calligraphy of Drought' by G.W. Bot.,
Aus. Linocut, 57 cm x 75 cm
(27½ in. x 29½ in.) 1998.
A 3-block image using oil-based ink
and printed on an etching press on
BFK creme paper. G.W. Bot writes,
'I love cutting, I think it is a way of
being part-sculptor – a relief sculptor
– even though more and more I just
seem to scratch at the surface'.

The tactile physicality of living in the
vast spaces of an ancient continent –
where every exposed surface is subject
to the sculpting forces of the natural
elements – has immediate and
satisfying parallels with the relief
printmaker's dialogue with surface.
This sensual touch of nature inspires
a growing affinity for neighbouring
Chinese and Japanese printmaking
techniques which have lightened the
weight of European tradition.

'no small tempest' by Pamela Challis,
Aus. Woodcut on chine collé,
45.5 cm x 57.5 cm (18 in. x 22½ in.)
1995. Hand-printed on Japanese W10,
coloured from the back with pastels,
and adhered to the base paper, BFK
creme, using Japanese rice paste.

'Running Cockerel' by Michael Rothenstein, UK. Colour woodcut and screenprint, 51.4 cm x 142.4 cm (20 in. x 56 in.) ed. 50, 1981. Power tools used, woodcut printed on a Columbian press.
Courtesy of Birmingham Museums and Art Gallery.

Michael Rothenstein was one of the most innovative printmakers of the 20th century for whom I worked as a studio assistant during the early 1980s. I recollect his words, 'When we cut into the flowing grain of wood we are conspiring with the same life force of energy that compels a child to carve his name upon a desktop or for lovers to establish their relationship with their scratched initials on a tree'.

I was a sculptor and knew little about the world of relief printmaking when I began working for Michael. This was a new apprenticeship with a master of the medium. He instructed me in all I practice and teach today from the sharpening of gouges to the printing of complex blocks. Michael often talked of the many printmakers he knew, of Frasconi in America,

'Tränin-Kopf' by Otto Mindhoff, Germany. A three-block linocut, 35 cm x 52 cm (13¾ in. x 20½ in.) ed. 100, 1996.
A student of the important woodcut printmaker, Helmut Grieshaber, Otto is curator of The Xylon Museum and Workshop, Schwetzingen, Germany.

'Diver No. 1' by Jeanine Coupe-Ryding, USA. Woodcut, 104 cm x 76 cm (41 in. x 30 in.) ed. 1, 1998.

Jeanine writes, 'In flight, the figure is abnormal, free from the day-to-day pedestrian experience.' She adopts a painterly approach to create an atmosphere of living dynamism. Each image is composed of layer over layer of ink, sometimes printing up to twelve different blocks, using one to four colours per printing. 'While carving the blocks is my favourite part, I make extensive use of stencils which are used as masks during inking. Working with stencils allows me the flexibility to work directly from my drawing, instead of having to translate the drawing into a 'cut' image.' Jeanine uses Rives BFK and Stonehenge paper for their strength, Japanese carving knives and a Dremel machine tool to create free-hand style lines.

of Munakata in Japan and of his days living in a house opposite Edward Bawden. I inked and printed many of his woodblocks and became familiar with that same vigorous force of cut which recalled so well his predecessors, Gauguin, Edvard Munch, Kirchner and the German Expressionists.

Michael's son, Julian Rothenstein, set up The Redstone Press in London. In 1987, Julian reproduced in offset litho a boxed volume of woodcuts by the Belgian artist, Frans Masereel. In narrative progression and without any text, the prints describe two novels, *The Idea* and *Story without Words*. It was Julian's own design that both stories should end in the centre of the book! One of the stories is inverted. In other words, the woodcuts are printed upside down so that in order to obtain a continuous forward or 'right reading', the reader must rotate the book half-circle in the hands. Concept, technique and construction are perfectly entwined and the fruits of Masereel's labour, which is his art, become central to a masterpiece. As relief printmakers we see an immediate parallel with our own constantly revolving, alternating dialogue of practice and invention.

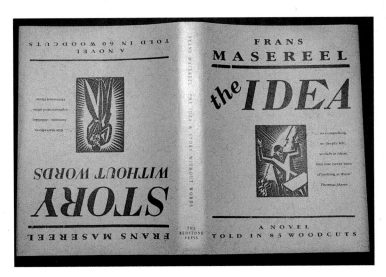

The front and back covers of 'The Idea and Story without Words' by Frans Masereel.
Designed and published by Julian Rothenstein, The Redstone Press, UK. 15.6 cm x 11.5 cm (6 in. x 4½ in.). Printed in offset litho, 1987, from Masereel's original woodcuts. Frans Masereel was the founding member of The Xylon International Society of Wood Engravers. The Society began in Zurich in 1953 and today has branches in many countries. Xylon holds many international exhibitions whose members' prints demonstrate a great diversity of technical approaches to the medium.

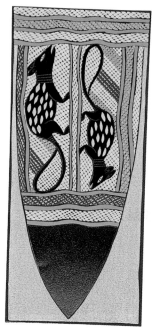

'Sacred Digging Stick' by Naminipu Maymuru, Aus. A three-part triptych, vertically upright with the large head at the top. A combination reductive linocut with additional blocks for cross-hatched areas. Total dimensions: 138 cm x 21 cm (54³/₁₀ in. x 8¼ in.) ed. 75, 1996.

Naminipu uses traditional carving techniques introduced hundreds of years ago by Macassan seafarers. Images of the Dreamings have been transferred to the vehicles of canvas, linoleum, screen stencil, lithographic, photopolymer and etching plate.

Chapter 1
SURFACE MATERIALS

■ People have been making prints from the materials of their immediate environment for thousands of years. From prehistoric engravings incised and filled with raw pigments upon cave walls to the present-day print that retraces the blade of a computer-driven router, the essential stamp upon a material form becomes yet another 'proof' of our evolving continuum.

The stencilled and patted application of ochre-smeared hands and feet pressed onto rockfaces in Australia are some of the earliest surviving relief monoprints. There are spectacular examples on the walls of Kenniff Cave in the Carnarvon Ranges of Queensland. As time passes and more hands have superimposed the first artist's signature, so each generation applies a fresh layer of imprint upon the sacred ancestral rock. The creative process never ends. The ritual bonds all indigenous Australians to their past, uniting each and every one with the Creation spirits. Hundreds of hands float as a red ochre cloud over the centuries, accentuating a dimension which transcends the consciousness of a linear time. It is this same association with the infinity of creativity that persists in the group consciousness of the contemporary printmaker. Our vision changes as the surface of intent is magnified by the diversity of available materials.

We live in an age where we are surrounded by a myriad of materials which offer an enormous range of surfaces suitable for cutting into, mark-making, stencilling, embossing or simply leaving untouched to explore for print potential. Many manufactured 'readymades' have intriguing textures, perforated and stamped patterns to exploit. The natural world provides wonderful possibilities for additional textures on a lino block as leaves, grasses and feathers are placed on inked areas before printing. A print can be made from any material that has a sufficiently flat surface to hold ink and the strength to take the pressure of hand, *baren*, spoon or press.

Hardboard, medium-density fibre, plastic, acetate, rubber sheeting, metal plates, cast blocks of plaster, found objects, polystyrene foam board, fabrics and card are equally at home in the printmaking studio as the familiar wood and linoleum blocks. Often discovered amongst the contents of a builder's rubbish skip – for free – organic and man-made materials alike, they all respond to the printmaker's touch. Yet most professional relief printmakers remain faithful to the surfaces of wood and linoleum.

Wood

Long-grain for woodcuts

The traditional, universal medium for woodcuts is plank wood, a length of wood that is cut parallel with the flowing sap and grain in a tree trunk. It is commonly known as 'long-' or 'side-grain' wood. My own woodcuts are made most frequently from pine planks or birch plywood but I will try any wood surface which resonates with printing possibilities – be it the roughest section of discarded timber with a wide open grain or the smooth, soft base of an old cupboard drawer.

Pine has a vigorous grain which expresses a lively movement in the print. Parana and white pine cut better than red pine which is inclined to be be tough and knotty. A large pine block can be made by lap-jointing, gluing and clamping two or more planks together. The join may be strengthened and possible warping restrained by screwing two narrow strips of metal across the end grain on each lateral side. Most timber merchants sell plank wood which has been kiln-dried rather than slowly seasoned. Check carefully for any warping if you want to start cutting straight away or if storing, lay down planks and boards horizontally off the ground in a dry, stable atmosphere, stacked so air can fully circulate around each board.

If you are concerned about conserving certain endangered species of wood, ask the timber dealer for information about the wood's origin, methods of tree cultivation and replanting. Parana pine is a beautiful softwood for carving blocks but on learning that it grows in the Amazon forests I have resisted using it for some years now. However, my local timber dealer believes that it is good conservation to keep purchasing Parana because if the market demand is maintained then a stockpile of uncut wood is avoided. Without a demand for the wood, the remaining trees are burned down to clear space for farming. Instead, with a continuous and steady demand, young trees are planted so renewing the forest and regenerating essential carbon dioxide. It is a point of view based upon the dealer's practical knowledge and experience and raises a prime issue of concern for every printmaker who uses wood.

Printmakers working on long-grain have numerous hardwoods and soft woods from which to choose. In general, soft woods are easiest to cut. Standard UK plank thicknesses range from 2.5 cm – 7.5 cm (1 – 3 in.) with practical widths for the printmaker ranging from 15 cm – 30.5 cm (6 – 12 in.). Most timber dealers will machine-plane planks to your required thickness and many sell laminated plank boards ideal for using as ready-made blocks.

Hardwoods (notes in italics courtesy of Professor Joel Feldman, Southern Illinois University, USA)

Easy to cut include:
Balsa wood: *may be drawn into with ballpoint pen, etc.*
Mahogany: *plank: fast-cutting, crisp detail. Needs sharp tools.*
ply: fast-cutting, open-grained.
Lauan: *if well-chosen, very effective for moderate detail.*
Makore (Cherry Mahogany)
Poplar: *holds detail but the knife grips the wood.*
Basswood plywood and lumber: *cuts easily, needs sharp tools.*
Shina (Japanese lime): *excellent, similar to Basswood, but perhaps a bit crisper. Capable of holding fairly complex detail. An ideal wood for beginners.*

Medium cutting:
Apple plywood: *similar to Baltic Birch. Maple faced on an alder core. Crisp detail and very stable.*
Ash: *medium-hard.*
Birch: *hard, similar to maple. Works best in plywood.*
Cherry plywood: *ideal, cuts easily, holds detail well.*
Katsura: *difficult to obtain.*
Lime (linden)
Magnolia
Pear: *ideal for intricate detail, consistent grain, little if any movement ahead of tool. From the point of control, the best wood I have cut on. It does not lend itself to quick, spontaneous cutting.*

Difficult to cut:
Beech
Elm
Maple
Sycamore
Walnut

Softwoods
Easy to cut:
Parana pine, White pine, Larch, Redwood.

Medium cutting:
Red cedar (medium-hard), Cypress, Douglas Fir, White Fir.

Plywood (many will find this the most practicable choice)
Plywood is produced by revolving the tree trunk against a saw blade to peel off a continuous sheet of thin wood. The length of 'trunk' sheet is divided into pieces which are compressed and glued together with the

SURFACE MATERIALS

grain direction of each piece set at alternating right angles. The 'cross weave' of grain provides strength and reduces warping. Like all sheet and board wood, plywood comes in the standard sheet size of 244 cm x 122 cm (96 x 48 in.). Generally plywood has three layers. Multi-ply can have five or more layers. Ply and multi-ply sheets are available in 4 mm, 6 mm, 9 mm, 12 mm, 18 mm and 25 mm (⅛, ³⁄₁₀, ⅜, ½, ¾ and 1 in.) thicknesses.

Birch, Far Eastern and shuttering plywood

Birch plywood has consistently sound, well-bonded laminations running right through the sheet. Birch is usually the most expensive plywood but it is worth paying the extra cost if you are looking for a consistently smooth, close-grain cutting surface.

The looser, more textured surface grain of Far Eastern plywood has a strong appeal for many printmakers. Shuttering is the cheapest of all plywoods. It is very tough with knotty pine facings.

Blockboard

Blockboard has Far Eastern ply facings on both sides with a softwood strip core of pine between. Blockboard comes in 9 mm, 12 mm, 18 mm and 25 mm (⅜, ½, ¾ and 1 in.) thicknesses and is more rigid than plywood.

'Shoreline 2' by John Pratt, Aus. Woodcut, 57 cm x 120 cm (22½ in. x 47¼ in.) 1995. John's woodcuts have a direct association with his immediate landscape in Australia which inspires his work. He writes, 'It is a compelling landscape and one not difficult to respond to'. And of his affinity with wood he adds, 'The immediacy of the woodcut has been its major attraction – there is little technical mediation between the mark imposed and the resultant print. I use coarse builders' ply already inflected by grain and I much enjoy the liveliness of surface already there and its toughness of resistance. Cutting is done partly with conventional chisels and partly with electric drills and brushes. The latter often amplifies information already suspended within the structure of the wood.'

Printmakers develop a great sensitivity to the response of the wood to the cutting tool; I prefer the flexing spring of plywood to the ungiving firmness of blockboard.

Veneered ply

Japanese woodcut printmakers use veneered ply with sheaths cut as thin as 3 mm (⅛ in.). The veneer is stripped from sheets of Lauan, Rawan and Shina (Lime) plywood. Other popular veneers are Cherry, Katsura, Linden (Lime), Poplar, Siebald's Beech, and Silver Magnolia.

'Breath' by Simon Lewandowski, UK. Woodcut on canvas with screenprint and paint, 122 cm x 142 cm (48 in. x 56 in.) 1996.
Simon used a machine router to cut the plywood block.

Medium-density fibreboard

Medium-density fibreboard (most commonly known as MDF) is a very stable, extremely rigid board made from compressed fine dust and formaldehyde. The dust is dangerous to inhale and a respirator or dust mask should be worn when sanding. Some MDF has a high measure of formaldehyde. Before purchase make sure that your supplier stocks MDF with a low level of formaldehyde content. MDF is available in standard 244 cm x 122 cm (96 in. x 48 in.) sheets and a range of thicknesses (3, 6, 9, 12, 18 and 25 mm or, ⅛, ³⁄₁₀, ⅜, ½, ¾ and 1 in.). It is an extremely robust material which cuts 'cleaner' than hardboard. Although MDF has an impersonal feel it is a useful and economical alternative to wood and lino. However, the unyielding properties of MDF have snapped off the tips of many of my knife blades.

'Watchtower' by Peter Dover, UK. 97 cm x 76 cm (38 in. x 30 in.) ed. 10, 1998.
The handmade paper was prepared with a colour wash in varying intensities using litho colour let down with white (mineral) spirit. Then the paper was lightly burnished with a soft cloth before the wash dries. This gives a soft matt surface important to the play of surface of inks applied from the plates. Plates of MDF, plywood and a discarded routing plate were printed by hand burnishing.

Hardboard (Masonite in the USA)

A timber particle board, hardboard is produced in standard 3.2 mm and 6 mm thicknesses. It is a very good substitute for lino when block-printing large areas of background colour. Shapes for jigsaw and multiple blocks can be cut out easily with handsaw, electric jig cutter or bandsaw. The smooth-faced surface is suitable for knife cuts, gouging and texturing with electric sanders and wire-brush attachments. Hardboard has a looser composition than lino so low relief marks tend to be less clearly defined. Resulting prints have a correspondingly rougher texture in appearance. However, it remains one of the cheapest materials and stores well. A thin coating of shellac applied after cutting reduces surface flaking when rolling up ink.

I keep a few sheets of 3 mm (⅛ in.) hardboard by the platen press to build up the type height beneath the printing block.

Chipboard

Is another particle board, much coarser than hardboard, which is produced in 6, 9, 12, 18 and 25 mm (³⁄₁₀, ⅜, ½, ¾ and 1 in.) thicknesses. I was surprised to learn from Jill Watton of Intaglio Printmakers that a lot of printmakers use chipboard for cutting. It has an intriguing texture in prints but I have found the surface unsympathetic for relief cutting. The irregular composition of coarse wood shavings inhibits definition of cut and challenges the sharpest cutting tool. Meanwhile, 12 mm (½ in.) thick chipboard makes an excellent baseboard for the platen press.

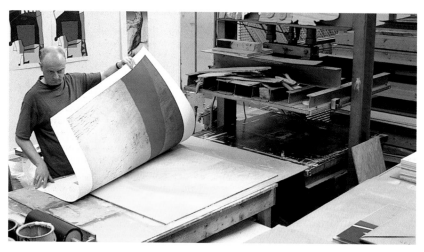

Bob Saich of Advanced Graphics, UK, registering paper on an OSB block for printing on the studio's wood-veneering press. Bob Saich and Louise Peck run the studio which prints, exhibits and publishes limited editions of woodcuts and screen-prints (many combining the two processes using oil-based screen inks for both operations) by a stable of artists who include John Walker and Albert Irvin.

Oriented Strand Board (OSB)

These boards (6, 9, 12, 18, and 25 mm / ³⁄₁₀, ³⁄₈, ½, ¾ and 1 in. thicknesses) are instantly recognisable by the heavily textured surface created by the resin-held strips of compacted pine waste. I found OSB being used by Bob Saich at Advanced Graphics, London. Bob said, 'Apart from shuttering ply, OSB is the only wood that will stand up to the immense pressure of the veneering press, anything else gets smashed to bits'.

End grain for wood engraving

For qualities of finely incised wood engraving, the printmaker employs the densely compacted surface of the 'end-grain' block which is cut from a carefully selected 'cross-sawn' section of hardwood – a slice across the tree trunk.

'Jose Pasada and friends' by Jim Todd, USA. 30 cm x 40.5 cm (11¾ in. x 16 in.) 1993.

The most commonly used hardwoods are: boxwood, apple, cherry, hornbeam, pear, holly, hard maple and lemon wood. Boxwood, especially English boxwood, has superb qualities for engraving. The tree rarely grows wider than one foot in girth, so by nature the blocks are small.

Blocks can be purchased specially prepared by skilled craftspeople. After a meticulously regulated process of 'curing' and stacking (which may take up to three years before completion) the initially rough blocks are cut down and sanded to smooth rectangular perfection for customers. The largest blocks are composed of a number of small blocks glued together at the sides with mahogany fillets and tongue in groove joins.

According to Martin Lawrence of T.N. Lawrence, (a leading firm of printmaking supplies in the UK) a standard, jointed boxwood size is 10 cm x 7.5 cm (4 in. x 3 in.) and

One of a series of portrait engravings of famous printmakers using end-grain maple and hand burnishing. In the 1995 catalogue of the 75th anniversary exhibition of The Society of Wood Engravers entitled 'Wood Engraving, Here and Now' Jim writes, 'I think my love of wood carving came from my childhood in Seattle, Washington. I was in awe of the wooden totem carvings of the Kwakiutl Indians, and that, I am sure, has some connection with me becoming a wood engraver. Later, I was influenced by the engravings of Leonard Baskin, Misch Kohn and Lynd Ward, who worked with great imagination and technical freedom. My biggest frustration has been with the high cost and small size of end-grain blocks, so whenever my finances permit, I engrave larger prints.'

SURFACE MATERIALS

the largest is 17.5 cm x 12.5 cm (7 in. x 5 in.). Boxwood is classified as Grade A wood whilst holly, pear and lemon wood are Grade B. Lemon wood is not from the lemon tree but is the generic name given to South American hardwoods, one of the most popular brand names is Degame. The largest jointed lemon wood blocks are 25 cm x 20 cm (10 x 8 in.). In addition, some printmaking suppliers sell economical packs of off-cuts

'Deep Pool' by Edwina Ellis, UK/Aus. An engraving from type height thick blocks of 'Delrin' acetal homo-polymer, 206 mm x 91 mm (81 in. x 36 in.) ed. 40, 1997. Edwina engraved three blocks, printing in the order of black, yellow, and finally red. She keeps her oil-based colours 'thin' and prints on dry paper using Zerkell, an extra calendared (smooth) paper which John Purcell sells as 'Edwina Ellis 111'. She places seven sheets of packing paper in the tympan on her Albion press. The thick blocks can be resurfaced after an edition run so they can be recycled several times. Slips of paper or card 'make ready' are placed beneath the reduced blocks to rebuild the height for printing and correct any uneven pressure points.

which are left over when the rectangular block is cut from the end-grain section of the trunk. These off-cuts, in assorted shapes and sizes, are ideal blocks for beginners.

Engravers seek out alternative materials when they find themselves frustrated by price, smallness of block size or without access to their favoured wood. In the 1940s, when Turkish boxwood was unobtainable in Australia, the printmaker Helen Ogilvie, in typically Antipodean pioneering spirit, discovered an excellent substitute for engraving in Tasmanian Myrtle.

Plastic sheets: an alternative to end-grain

Edwina Ellis, an Australian working in England, engraves into type height Tecaform AD or Delrin, trade names for an economically priced nylon-based acetal homopolymer (plastic) which in sheet form allows her to work on a much larger scale than the diminutive end-grain. The acetal can be purchased in 1 m x 2 m (40 in. x 80 in.) sheets from main distributors or, in smaller pre-cut sizes from printmaking suppliers. There are numerous thicknesses, the most popular for engraving are between 3 mm and 5 mm (⅛ in. and ⅕ in.) which can be cut to the required block size and mounted to type height on wooden bases for printing. 'Delrin' sheets are opaque white and may be dyed to show up drawing and engraving. Some surface preparation with fine wet and dry sandpaper prevents the tools from slipping on the smooth surface.

Anthony Christmas of The Hermit Press writes, 'Unlike wood, Delrin is very consistent but the slivers from the cut do not jump off so readily and sometimes need to be pushed off with the fingernail or the tip of a knife blade. The students rather like it. I think that anything which removes elements of preciousness and timidity of approach must be beneficial.'

'Resingrave'; an epoxy resin-layered fibre board, has similar properties to Delrin and can be purchased in the USA by contacting Richard J. Woodman (see Suppliers List on p. 119).

Linoleum

As a sculptor I rejected linoleum, initially preferring to work with the natural force of wood. Perhaps the drab grey/brown reminded this post-war baby too much of utility furniture, institutions and school floors!

In total contrast, colour and light permeated the studio and art of Michael Rothenstein. At his Argus Studio I witnessed and was infected by Michael's marvellous enthusiasm for exploring any material. Nothing passed his gaze as print potential and he made scores of melodies on lino. Blocks were stored everywhere from years back – Michael was by then in his mid-70s – he had cut, gouged, hammered, etched, jigsawed, gessoed,

*'Black Pagoda' by Michael Rothenstein, UK. 73.2 cm x 58.3 cm (28¾ in. x 23 in.)
ed. 50, 1969.* Courtesy of the Birmingham Museums and Art Gallery.
Two plywood blocks were printed in purple (top) and purple-blue (bottom) with
seven screenprinted circles on top followed by a halftone block printing of the
pagoda. The halation around the circle was created by a 'double-deck' plywood
block. This was a thin block with a second smaller circular block placed beneath.
When the print was taken from the upper block, the reduced pressure on the
perimeter created a halo impression around the circumference.

and combined lino with many other media. Since the age of 40 when he began printmaking, he pioneered his unorthodox path through the medium, changing the face of printmaking in the UK. Printing from wood, lino, plastic, metal plates, hundreds of 'found objects' and combining the results of the relief press with the sophistication of photographic screen processes, he revelled in creating the seemingly impossible print. I took another look at lino and changed my mind.

Lino with its smooth, soft surface allows for crisp, bold imagery which can be cut out and printed very quickly. These qualities make it ideal for social and political imagery which demand a dynamic forceful statement. Linocuts were used by Soviet artists during the Russian Revolution and for the (Federal Art Project) American Works Relief Programme of the 1930s Depression. As a low-budget means of mass communication, artists as far apart as Poland and South America armed with a knife, lino, ink, paper and the courage of self-expression, have made enduringly powerful and provocative images.

Later technologies have given us the many textured and patterned surfaces of vinyl and rubber flooring tiles. These materials are easy to work into with hand tools and can be cut up quickly to make jigsaw blocks. Smooth vinyl is often used by engravers.

'Rat Racer' by Bill Fick, USA. A single linocut block printed in black on dampened Somerset Velvet paper, 89 cm x 61 cm (35 in. x 24 in.) ed. 12, 1998.

Printed by the artist on a Martech intaglio press at Cockeyed Press, New York City. Bill spent his early childhood in Venezuela. 'I read Mad Max comics and was exposed to folk art, masks and religious objects...this print is about greed. By using the mongrel rat/dog character I am pointing out an ugly side of human nature. About the way it looks – for several years I have been opening up my images and doing away with the squared-off border. The character is free and is only constrained by the borders of the paper. I brush gesso on the linoleum which gives some tooth for the drawing done with a brush and black India ink. I make a 100% commitment to the drawing. I carve the block without proofing.'

'Stenocut' stencil plates

Sue Anne Bottomley, an American artist, is the innovator of the 'Stenocut' relief method. She uses a soft, thin, rubber stencil commercially intended for sandblasting designs on wood and stone. The stencil, which is available from signmakers and monumental masons, comes in rolls, 63 cm x 915 cm (25 in. x 10 yds long). It can be drawn on and cut easily with scissors and lino-cutting tools. The surface cuts like butter and prints with clean edges. The rubber plate has an adhesive backing so it can be fixed to a smooth surface card or plastic board to provide a rigid base. Plates stand up to editioning and can, in some cases, be printed as intaglio. The surface requires no sealing agent for water-based inks but before contact with oil-based inks it must be protected from the corrosive action of both the solvents and the inks with a brush coating of acrylic medium.

See p. 63 for Sue Anne's method of transferring a photocopied image to the plate surface. More information about these processes can be obtained from her web site (addresses in Suppliers List on p. 121) or found in *Handmade Prints* by Anne Desmet and Jim Anderson, A & C Black, 2000.

Alternative materials

Other surfaces which have been transformed beneath the relief printmaker's hand will be explored through the upcoming chapters. The author will discuss alternative materials and methods such as mixed material blocks, printing on fabric, etched metal plates, photo-relief plates, Heliorelief, Asiatic printing, embossing, plaster, collage, card, lino etching, book and installation art.

Chapter 2
THE STUDIO SPACE, TOOLS AND CUTTING PRACTICE

 ## Organising the studio space

The mental freedom for creative expression is found in the personal workspace. This may be a communal workshop or a private studio. Each setting requires a discipline of action. Method and order underlie the guiding principle of endeavour. Tools and equipment, from the smallest blade to a handsome printing press, are the children of the artist. We take care of them as we care for ourselves. We create a space which identifies the needs of the child, and learn to love and respect their virtues. They give us great rewards if we love them. I have old and worn tools which I have learned to cherish. This is the path which Munakata and Rothenstein understood, well maintained tools being crucial to thier art.

Health and safety
Integral to the working process is a conscientious regard for personal health and a concern for the natural environment. Here are essential guidelines for a safe and efficient relief printmaking studio:

1. A good source of natural light or 'daylight' electric lighting, particularly over the inking slab and press.

2. Good ventilation. Instal an extractor fan if you intend to use solvents, oil-based inks and sanding machinery.

3. Position your equipment so that it harmonises with the creative procedure. Provide sufficient space for a sturdy block-cutting bench within close proximity of electricity power points. The bench should be high enough for you to stand without bending whilst working. The addition of a vice is useful to hold sharpening stones or you can pin small wedges to a work surface to hold the stones.

4. Allow plenty of open space to be able to walk around the press and have a storage surface nearby for packing material. Leave on or near the press: clean paper finger 'grips', talc for inky fingers, wooden spoons or barens and a minimum of two heavy weights for burnishing.

5. Include a waist-high inking surface. Use an ink slab made of white plastic, marble, stainless steel or a sheet of plate glass with white paper spread beneath to give a clear base for all colours.

6. Hang your rollers on a horizontally suspended rod above the inking slab, keeping clean and dirty rags in separate boxes beneath the bench.

7. Lay gouges, chisels and knives on a soft cloth or mat to protect the blades.

8. Other essentials are: a paper-dampening table, standing or hanging drying racks for prints, a sink with refuse catchment mesh covering the drain, and shelves for inks, tools and assorted paper.

9. Store solvents and chemicals in a fire-proof cupboard.

10. Use a barrier cream and wear surgical or rubber gloves when using any solvent or chemical substances including oil-based inks. Keep a first-aid kit with eye-wash solution in the studio. Use vegetable (sunflower) oil or 'Vegeol' for cleaning rollers, blocks and ink slab in preference to white (mineral) spirit, kerosene or gasolene. The latter are extremely damaging to health.

11. Wear protective eye goggles and a respirator or dust mask when using electrical cutting and sanding tools on all materials (including plastic/car body fillers, resins and polystyrene).

12. Always secure the work when cutting with any tools. I like working at the corner of my bench with the block secured to the two adjacent edges by two, usually 12.5 cm (5 in.), G-clamps. In this way both hands are free to concentrate on cutting. My back is kept straight and I can move around the two nearest sides of the block so that my whole body is actively engaged in the work. This posture is less tiring than sitting down and I can maintain a near-vertical perspective (rather than a slanted view) of the surface so I have a vantage point that is consistent with my objective.

Small squares of thick card inserted between the clamp grips and the block prevent indentations to the surface. Alternatively, an 'L'-shaped bench board clamped to the corner of the bench, allows quick and easy rotation of the block whilst ensuring a firm supporting framework for cutting. Most colleges supply students with a bench board which has two sections of 5 cm x 2.5 cm (2 in. x 1 in.) baton screwed in parallel on opposite edges. One baton is fixed below the board to provide a wedge against the edge of the workbench. The other baton, fixed along the top edge at furthest remove from the body, acts as a pressure stop for the block. These boards function well for gougecutting but provide little functional or safe support for knife and machine cutting.

The tools and practice of wood and linocutting

Round and shallow curved gouges
V tools
Heavy-duty craft knife and blades
Metal-handled surgical scalpels
 (Swann Morton no. 4 handle,
 no. 22 blade)
Japanese gouges
Japanese knife
Carpenter's chisel
Mallet
Multiple tool
Handsaws, files and rasps
Wire brush
Steel ruler
Sandpaper (fine to coarse grades)
Smoothing plane
Oil stones: Fine, medium grade
 and Arkansas
Slip stone: Arkansas
lubricating oil
Leather strop
Table-top bandsaw
Power tool with heavy-duty sanding disc, rotary wire brush and flexible
 rotary wheel drive attachments
Jigsaw cutters, fixed blade and turning blade
Dremel motorised engraver and assorted cutting heads
Router
Bosch PSE 180E motorised gouge and v-tool cutter

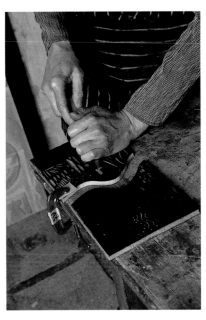

Standing up to cut a woodblock with a long-handled gouge.

The quartet: knife, gouge, chisel and mallet

These are the four synthesising power tools of the hand. Each instrument orchestrates a specific energy to the visualised image. Their design has changed little in centuries, only their use has fluctuated. After the great medieval period of woodcutting and the magnificent temporal achieve-ments of Durer and the German masters, the woodcut fell beneath the axe of metallurgy. The four tools rested until Thomas Bewick (1754–1828) resurrected nature in bold yet timid reformation during an age in which the imperialism of the scientific mind forgot the necessity of the heart. He procured a precarious but valiant battle against the new technology of metal engraving which indeed he had mastered. At first acquaintance his wood engravings appear to render the subject only – 'typically english' –

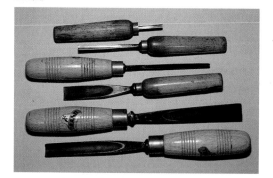

Assorted gouges.

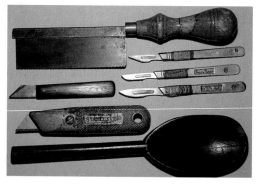

Clockwise from top: handsaw, three surgical scalpels, wooden burnishing spoon, Stanley craft knife and wooden-handled knife.

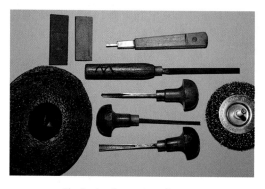

Clockwise from top: slip stone, Arkansas sharpening stone, Japanese gouge, multiple tool, rotary wire brush, two mushroom-handled gouges and v-cutter, and a heavy-duty rotary sanding disc.

nature and wildlife now laced with nostalgia – but deceptive. Beneath his work are the cuts. He understood that his subject and craft were the same and was able to portray the whole as a system of light. He saw beyond the object, be it a bird or a man in a tree, to a landscape consisting solely of severed light, i.e., the cut block. He knew that each tool and the manner in which it was swung corresponded to the quality of light perceived. He was fascinated by his subject – the bounce of light on matter. A misinterpreted visionary, his work is regarded as somewhat quaint today by many progressive artists. Bewick saw that when the cut was made nothing was destroyed.

The knife: the fundamental cutting tool

You must be like a fencer who never misses the point of visualisation. You have already learnt to hold the handle, to feel the grip and make the mark. Is it what you want? Do the cuts sum up the total of experience? If they don't, there is something preventing a balance between the hand and the brain. The good carver does not blame his tools. When at first I became a sculptor I did not carve. I constructed instead. Now that I have carved into wood I have come to know the woodblock. It likes good tools. Keep them sharp and they will glisten through the wood.

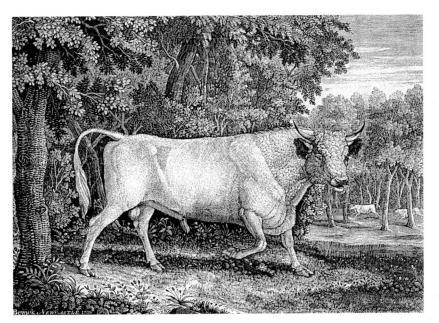

'Wild Bull' by Thomas Bewick, UK. Wood engraving, 14.6 cm x 19.6 cm (5¾ in. x 7¾ in.). Copyright of The British Museum.
This print is regarded as Bewick's *tour de force*. By mischance, he left the block on a window ledge and the sun split the wood in two.

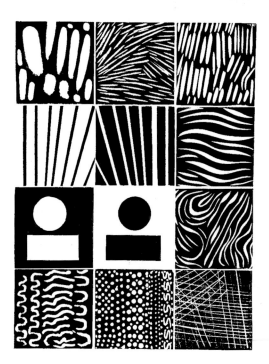

Mark-making on lino with hand tools and Dremel engraver.

Top row from left to right: Large gouge, v-cutter, small gouge.

2nd row: positive and negative cutting using a Stanley craft knife and steel rule; Stanley craft knife.

3rd row: positive and negative forms; surgical scalpel knife.

Bottom row: Dremel engraving tool lines and punctures; cross-hatching with the teeth of an old saw blade.

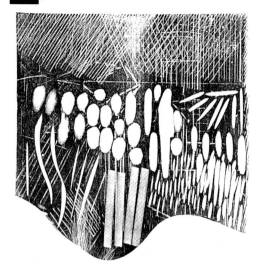

Mark making on wood with hand tools:

Top: cross hatching with a tenon saw; right and centre: assorted gouges; bottom centre: large multiple tool; bottom left hand side: scalpel and craft knife cuts. A rough file has been dragged down the right hand edge. The old, worn piece of wood already carries a previous history of background marks.

Hands and tools should be warm. If you are ambidextrous the warmth comes from the advantage of transcrossed references of information between mind and body which enable the cutter to unconsciously comprehend the polarities of both hands. Left-handed fencers are hard to beat. Many cultures restrain the use of the left hand. It should be used more frequently by right-handed cutters. Use both hands to hold the knife.

The knife advances towards the body, the gouge recedes. We breathe in to make the cut and breathe out when the tool is released. If the breath is *staccato*, so is the cut.

The angle you hold the knife is imperative to the breadth of the double cut 'v' groove. Side by side, two cuts are made into the wood, each made by determining the angle on the point of an imaginary line running between and below the two. When the point of contact is made, space replaces wood and reveals a triangular groove: 'v~~'. The flowing form switches in width and depth according to pressure, posture of hand and angle of blade. This kind of cut reminds me of a Matisse pencil drawing whose advancing and receding female contours lift off the paper in three-dimensional form. An inhalation and exhaltation of his subject and his vision, this artist and violinist compared cutting the lino to playing the instrument.

Feel your wrist that does the cutting, it is an electric fencer that foils the blow. The point at which the tip of the knife centres on the wood is crucial. All eyes are upon that point. It determines the mark. Your brain says 'switch on,' and the light travels down the neck to the heart and relates that message to the point. The rule is 'thinking is a mindless activity', so you forget what I have just said and cut it so that the image is sent from the heart (via the brain for co-ordination), down the wrist and onto the page. You see, you have printed it already without remembering a mark.

The gouge

From the crispest, hard-edged geometry of mechanical forms to the lightest of dancing lines, the gouge has the virtual scope of the welder's torch and the colourist's softest sable brush.

A well-made gouge is a cutting instrument shaped to make a specific kind of scooped cut and is designed to fit comfortably in the hand. The shape of the handle is crucial to the hold and cut. I use long-handled gouges because the tool is a straight line extension of my arm. Mushroom-handled gouges, originally designed for engraving, are good for small-scale work. Excessive pressure may hurt the palm if the cutting surface is resistant or the tool is blunt. Stout, long-handled tools are needed to cut broader, more expansive, gestural marks into large blocks.

We sacrifice the image if we hold the tool incorrectly. Study the way you hold your tool. Look at it as if for the first time. If there is an equilibrium of weight, mass and distance – that is the stretch from mind to body – you are ready to cut. Both hands are held behind the sharp edge for reasons of safety and control. One hand lightly clasps the tool, forefinger aiming down the shaft whilst the other rests beside with fingers ranged across both block and shaft in a spring touch pressure position. The first hand sweeps the blade into the wood, the second guides and controls the action of the former. It acts as a brake, indicating the point of entry and the place of departure.

Chisel and mallet

The chisel and mallet share the same chosen angle of delivery. The chisel is held lightly so it floats in the hand. It is the carrier of the mallet's message. Yet the mallet is held lightly too. Any tightness of grip distorts the message. It is the lightness of touch which carries the purest message. You tap as if there is nothing in the hands but gravity. Use the mallet and a strong-handled gouge for tough surfaces such as elm or knotty pine.

The multiple tool

This is an engraving tool and is a good tool for sharpening geometry or breaking up the darks from the whites in mechanical formation. It works well on plank wood where you guide the graver towards your body along the length of the grain. Use a steel rule as an additional straight-edged guide if you are describing unswerving symmetry.

Sharpening gouges and v-cutter tools

To keep curved gouges and v-cutter tools sharp, use axolite, carborundum or India stones finished with the fine, natural stone surfaces of Arkansas or Washita. A little oil may be added to the stone or like the Japanese, use a stone saturated with water. Make a 'finishing' strop by attaching a strip of leather to the bench. Rub the undressed side with razor strop paste before use.

In sharpening any tool the stone is secured and the body remains motionless whilst hands and wrists move in the manner of an automaton. To sharpen the outside edge of a gouge, roll the tool between the fingers or rotate the wrist and hand as the edge rolls across the stone in tandem. To sharpen the inside and remove the burr, press a slip stone level against the inside of the blade. Move the stone evenly up and down or rock from side to side along the edge. Strop the tool on the leather strip for a razor-sharp finish.

The v-cutter tool must be sharpened equally on both outside angles, keeping the bevel flat against the stone. Carefully sharpen the meeting point in the same way as the curved gouge.

When a tool blade becomes irregular or chipped, use a rotary grindstone to straighten the edge. Hold the tool at a right angle to the stone face and grind the edge evenly down to the lowest point of irregularity. Then hold the tool at a lesser angle to the stone face so that the existing bevel is ground back to meet the new edge. Finish by sharpening as before.

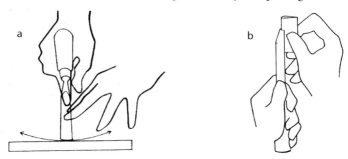

Sharpening gouges: a) The bevelled cutting-edge of the gouge is evenly rolled at an angle of about 18°. b) Remove the burr with a fine-grade slip stone.

Motorised power tools

1. Drill attachments: The swirling marks of a heavy-duty sanding disc describe three-dimensional form. Firmly clamp the block so that both hands are free to work the tool. Avoid using worn discs which have ragged edges. Rotary wire brushes open up the wood's surface. Run the brush parallel with the grain in empathy with the wood's life force.

2. The Dremel engraving tool has many attachments for creating numerous marks and textures on wood, metal, lino, plastics, and card. Other tool makes include: Flex Shaft and the Foredom micro-motor.

3. A soldering iron melts plastic for relief and intaglio work. A face mask should be worn.

4. A table-top bandsaw and jigsaw cutter (with a rotating blade) are indispensable tools for cutting blocks and plates.

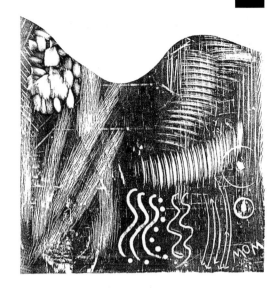

Top: Mark-making on wood with electric tools.
This block, cut on a table-top bandsaw, has the marks of a rotary sanding disc on the top and middle right side and G-clamp marks on the right. A variety of Dremel engraving tips have been active at the lower right and bottom edge with rotary wirebrush marks showing on the left. At the top left side are 'side-scoop' cuts made with a scalpel knife.

Bottom: 'All my Friends' by Grzegorz Dobieslaw Mazurek, Poland.
Single block linocut. 80 cm x 60 cm (31½ in. x 23½ in.) 1994.
Grzegorz produces images so exquisitely cut they have the appearance of mezzotints. He paints the lino in black before drawing the image and uses a mirror as he cuts. He fashions the tips of dentistry tools, scalpels, needles and gouges to cut the minute traceries of dot and line. He prints on 280–380gsm Fabriano paper after soaking it for five to ten minutes in a bath.

*'Pilgrim' by Peter Daglish, UK. Multi-block linocut, 52 cm x 40 cm
(20½ in. x 15¾ in.) 1998.*
Working from small, rough sketches, Peter Daglish draws directly onto the lino
with charcoal. He uses only lino for printmaking because 'it has a neutral surface
where every mark is my own. There is no room for errors with lino – I never make
corrections.' Note the sensual, musicality of wriggling gouge cuts and the hot,
exotic colours this jazz saxophonist produces with oil-based inks. Peter made a
separate block for each colour, printing on 250gsm Arches using an Albion press.

Above: 'Riverside Walk' by Săsa Marinkov, UK. Single plywood block, oil-based ink, hand burnished on kozu-shi paper, 57.5 cm x 88 cm (22½ in. x 34½ in.) ed. 30, 1996.
Săsa's prints show a clear understanding of the fundamental properties of wood. 'I usually print in black and grey. Using colour would be a luxury… for me cutting wood is a way of carving out a route.' Săsa's response to the often precarious balance between the opposites of order and disorder, construction and destruction, growth and decay is realised in her skilful fragmentation of the wood's surface. She employs the simple directness of the single-block process to create opposites of balance and tension between positive and negative forms.

'Training Session' by Joel Feldman, USA. Single block (lauan ply) woodcut, 185.5 cm x 96.5 cm (73 in. x 38 in.) 1993–94.
'I use Japanese carving tools working almost exclusively with gouges ranging from 1–24 mm width. 'I like the populist aspect of the woodcut coupled with its inherent simplicity. I interchange white and black line technique, maybe 70/30 or 60/40 white line predominating.' Joel usually paints his large blocks of Lauan or cherry plywood in black before drawing and cutting. He prints by hand with a wooden spoon on machine-made *Okawara* paper sometimes using a ball-bearing *baren* to 'set' the paper first.

Wood-engraving tools and practice

Barry Woodcock is an artist who understands the connecting points of science and art. His worktable stands equidistant between his computer and the woodblock. He sees a direct relationship between the pixels of the digital image and the particles of natural end-grain. He employs either medium according to the task at hand.

The correct way to hold an engraving tool.

If the engraving tool is too long for the hand, Barry clamps it by the shaft in a vice, removes the handle, then using a hacksaw, cuts an appropriate amount off the tang. He uses two grades of Arkansas stone for sharpening with no oil. He told me, 'The tools should have little but frequent sharpening. The face of the tool should be ground to an angle of 30–45°, and during sharpening must be presented flat and true to the face of the stone. He uses a circular motion for sharpening line tools and a straight line, forward and backward smoothing action for the space-clearing scorpers (some printmaking suppliers sell engraving tool jigs to maintain a fixed angle whilst sharpening on the stone). When necessary, he makes greater corrections with a slow-speed, fine-grade, rotary grinder before sharpening as described.

The shape of the graver (or burin) is fundamental to the cut. There is no need for a hollowed shaft, the graver is a solid beam of metal with a point that is squared or ellipsed to greet the grain. There are five standard line tools: the spitsticker, tint tool, multiple tool, graver and bullsticker and three basic space-clearing tools: round and square scorpers and chisel. Each tool has a specific function and a rank of several sizes.

The above photo shows the spitsticker in the correct hold. His left hand holds the block beneath the surface face to avoid a rogue slip, whilst his right hand makes the cuts. In a combination of natural materials, the block settles on a firm 30 cm (12 in.) diameter sand-filled leather cushion. Barry's right-hand cutting motion is parallel to his body. In other words his body 'gives' the point to the block which, perched in pivotal position on the elliptical surface, permits him to perform a balanced act of nature's cycle. There is a unison of movement as the left holding hand swings the block to meet the point of the graver held in the right hand. The thumb of the cutting hand remains in constant contact with the block, remaining stationary for short cuts and moving smoothly with the graver for longer cuts. See one of Barry's prints on p. 43.

An engraver applies a pressure which respects the natural range of the tool. The tools are designed to move with ease through the hard surface. Before cutting, the wood is lightly stained with a small amount of oil-based ink on a smooth rag. Indian ink should not be used as it has a carbon residue which builds up on the block. After staining, the design can be drawn with an H or HB pencil or traced on the block with carbon-copy paper.

Line tools
n.b. It is useful to write an identification code on the handle of each tool.

The spitsticker
In translation from German the spitsticker is 'the spike on the belt' as the elliptical point makes a round cut. The spitsticker, available in several graded sizes, is the most useful general drawing tool for cutting any kind of complicated, straight or curved line. It is also used for stippling. The thickness of a cut can be varied over its length by changing pressure and altering the vertical angle of the tool.

The tint tool
The tint tool is another line-drawing tool designed to cut straight or, upon occasion, gently curving lines of an even width. The tool is made in several sizes so that gradations of tints can be produced. The breadth of the cross section of each tint tool determines the width of the straight line.

The multiple tool
The engraver's multiple tool falls into the tint/line category. Manufactured with a series of parallel grooves on the shaft, this was a tool favoured by pressurised artisans rushing an image to print. Somewhat of a novelty if used too much for effect, the tool has a drawing capacity of three to six parallel lines. As Barry Woodcock informed me, 'It won't cut corners but, if used with reservation, it is good for stippling and cross-hatching.'

Square and lozenge-shaped gravers
These peck out the shape of the tool, i.e., a square or a diamond. The perfect 'pecked' square or diamond can extend from a minute spiked stipple to become a long, straight or curved line. Barry's professional eye prefers the aesthetic quality of the elliptical stipple created with the spitsticker.

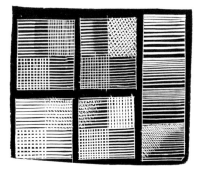

The bullsticker

The final line tool is the heavily built bullsticker whose charge upon the wood makes the greatest cut, creating curved or straight lines which swell out quickly from start to finish. It is the largest tool of the five engravers and its rotundity completes the cycle of the five linear cuts.

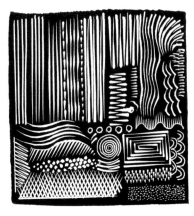

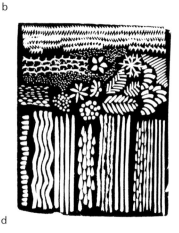

a

b

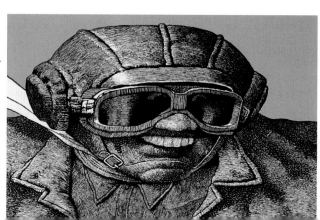

c

d

Samples of engraving on 'end grain' from: a) the spitsticker b) tint tools c) the multiple tool d) round scorpers. (Engraved by Barry Woodcock.)

'Tornado Pilot' by Jim Westergard. 15.2 cm x 22.9 cm (5 in. x 9 in.) 1997. Jim engraved the end-grain maple block with an electric engraver, burins and spitsticker.

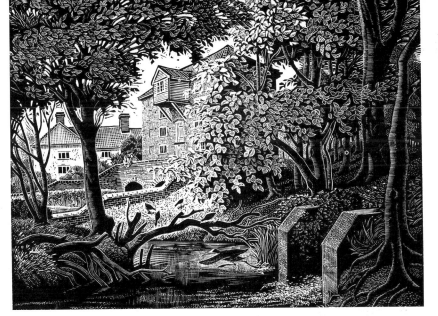

'Sproughton Mill' by Barry Woodcock, UK. Lemon wood engraving, 100 mm x 125 mm (4 in. x 5 in.) 1998.

Space clearing tools

The round and square scorpers

Scorpers are used mainly for clearing out white areas and for cutting broad white lines, coarse textures and stipples. Where a large space needs to be removed, rest the underside of the square scorper shaft on the edge of a plastic ruler and with the tool aimed to cut, push the point towards the area selected for removal. Keep the left hand pressed firmly down on the ruler to maintain a fixed guiding edge and cut out the surface area in front of the point. Continue holding the ruler in the fixed position with the left hand and move the tool sideways to cut out the adjoining space. This symmetry of process enables a precise space to be lowered to a constant and even level.

The round scorper is designed for stippling and decorative work. It can also be used for linocutting.

The chisel

The engraver's chisel is used for smoothing down uneven surfaces at the base of cut spaces or for gently smoothing and lowering an area of top surface. Gradual levelling of surfaces with the chisel lends modulation to form, offering tonal gradation and gentle transitions into lighter areas within the print. An etching scraper can be used to similar effect. The even pressure of a platen press reveals the subtle work of chisel and scraper most successfully. 'Make ready' slips of paper arranged beneath the block further assist the modulations of form and tone.

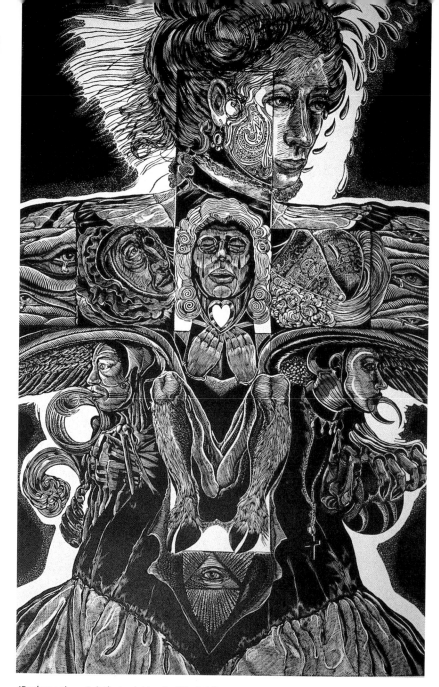

'Redemption, Brittle Lady' by Judith Jaidinger, USA. Wood engraving,
22.9 cm x 35.5 cm (9 in. x 14 in.) 1987.
Judith was trained at The School of the Art Institute, Chicago, and as a commercial
engraver at two of the last remaining engraving studios in Chicago. She writes,
'I have a Vandercook No. 1 proofing press and a commercial ruling machine that
dates from the late 1800s. Sometimes I incorporate mechanically ruled lines
along with free-style single-line engraving for interesting effects. Also I enjoy the
challenge of using multiple tools. I try to walk on the wild side, using traditional
methods for what can be disturbing and ambiguous subjects.'

THE ESSENTIALS OF PRINTING

 Presses

Platen iron press packing and printing

(A 19th-century cast-iron press used by many printmakers in the UK, the US, and Australia.)

Pressure for proofing should be judged so that the majority of printing height is controlled from beneath the block with thin boards. In this way only a premium of top packing is needed. The packing is placed either directly on top of the printing paper or for ease and efficiency, can be inserted between the frisket and the tympan during editioning. Six sheets of firm paper make sufficient packing within the frisket.

Soft packing (e.g. several sheets of blotting paper, newsprint or foam rubber) will squeeze damp paper into the recesses of a block whilst firm packing (e.g. firm paper or card) combined with dry printing paper picks up top-surface

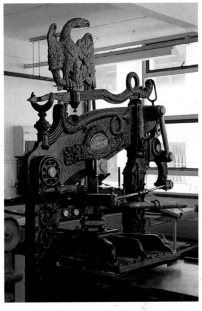

The Platen Iron Press. (Trade names: Columbia, Albion, Hogarth etc.) This is the most adaptable of all relief printing presses and is capable of printing blocks of varying thicknesses up to type height. Packing and 'make ready' are easily adjustable and the hand-pull makes the printer very sensitive to gauging the right feel of pressure. (Read more about this press in proofing and packing.)

information. I tape together wads of newsprint sheets for students to use. The packing should be crease-free and evenly positioned for uniform printing.

When printing a small block that is positioned off-centre on a platen press it is necessary to place another small uninked block on the other side of the bed. The additional block provides an essential counter-balance so that the top platen remains horizontal when lowered to print. Uneven

pressure and excessive force can cause serious damage to the sensitive mechanism.

Never apply dangerous and destabilising foot leverage against the platen carriage track when pulling a print. If you are unable to pull the arm across with relative ease exchange thick boards for thinner ones from under the block before checking your top packing to see if there is too much. I ask my students to respect the press – it is delicate and needs a kind hand.

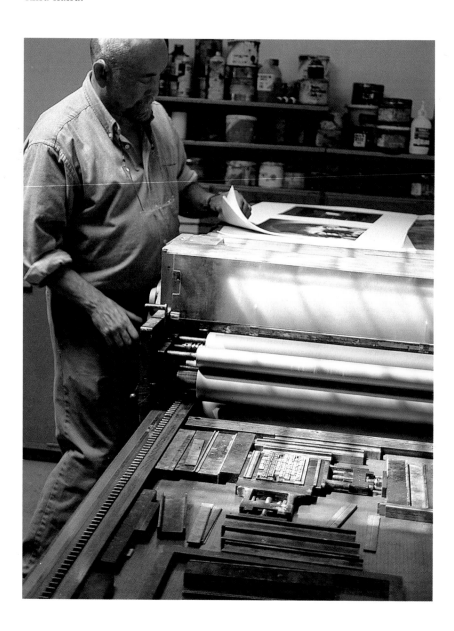

Modern presses

Right: The Intaglio Press. Linda Richardson's Polymetaal etching press. Linda places jigsaw blocks in pencil line registers for a multiple block linocut.
Many relief printmakers use intaglio presses. Master printers, Linda Richardson and Philip Pickering print on a Polymetaal JW–80, heavy-duty intaglio press with bed dimensions of 80 cm x 160 cm. The spring-mounted upper roller is raised to accommodate a wood, lino or card block. The roller is stabilised by two lino or wood runners, the same thickness as the block, placed along length sides of the bed. The inked block is centrally positioned on a thin sheet of card. Paper registration cuts or marks can be made on the block, with tape indicators on the bed or, as Linda demonstrates, using pencil marks on the card base.

She places one swanskin blanket between the roller and printing paper. During proofing, the upper roller is gauged to exert the minimum pressure needed for editioning. Excessive pressure causes heavy embossing, can squeeze too much ink from the block, and may crease the paper or even stretch thin lino. Shims of leather or cardboard can be placed under the spindles of the rollers to provide greater flexibility during printing.

Above: 'The Blue Boy' Screw-Top Relief Printing Press
This was devised by printmaker Michael Carlo and made by blacksmith Bob Stone of Suffolk (see Suppliers List p. 119). This low-cost, light-weight, portable press with bed size of 40.5 cm x 48.3 cm is safe and efficient for professional and college use. Michael Carlo says, 'It takes various thick-nesses of blocks as there is no fixed press setting. Very soon you become familiar with 'the kiss of the press' and the way it responds to your work. It makes printing very alive.'

Opposite: The Cylinder Press. (Models: Vandercook, Soldan and Fag.)
Numerous printmakers use this design of press which secures paper, ink and blocks in the firm grip of cyclical promotion. The Vandercook model is the most familiar to printmakers. However, Ken Campbell, maker of fine books, after printing his first dozen or so on a Vandercook SP20, now uses a Fag cylinder press for printing his line blocks, polymer plates, composited metal and wooden type. On this impressive German machine Ken Campbell superimposes the strong character of erudite artifice upon the facsimile of esoteric truth. All surface objects, aligned beneath the scrutiny of a printer's keen perspective, are subject to the machine's exactitude of precision. Ken frees all from the bold text of a personal and universal history, as before our eyes, he proceeds to raise up the evidence of a lifetime – his tran-scription of the master print – in ironic celebration of Fag's calibratory perfection.

'Harvest' by Michael Carlo, UK. Reduction hardboard cut with 15 colours,19 cm x 26.5 cm (7½ in. x 10½ in.) ed. 12, 1996, printed on 'The Blue Boy' press.

Michael writes, 'One day I started scratching, peeling and distressing the surface of hardboard. I discovered it is soft, flowing, delicate and fast to work on – and cheap! I do a simple drawing first and then cut out the whites, then print the first colour on 16 sheets of paper and I'm off – printing-cutting light to dark. I use paper stencils as temporary mask shapes, some torn to merge with other marks. The image grows and changes – I sort of chase it rather than drag into into shape. I print until I run out of board. I print wet on wet ink. This squashes the ink and produces richly textured ridges around shapes – like the heat of jazz – it moves.'

The Adana Platen Press.
An ideal table-top press for the rapid editioning of small blocks and letterpress type for books and cards. Angie West's 'Word' photopolymer plate is locked in the chase, inked and ready for printing.

Registration

Accurate registration is crucial for most printing except in the early stages of single block proofing. Reduction block prints, multicolour printing with more than one block, and prints accompanying letterpress type all need careful registration appropriate to the system used. Shown below are methods of registration accompanied by a few individual innovations.

Cut-triangle proofing register

Take two sheets of paper larger than the block and place one exactly over the other. Put a weight on top so neither sheet moves. Cutting right through each sheet, make two small neat triangular holes at two adjacent corners of both sheets. Tape one sheet down onto the bed of the press and centre the inked block on top. Draw a clear pencil line on the paper around the block. Lay the second sheet down for printing aligning the twin sets of holes.

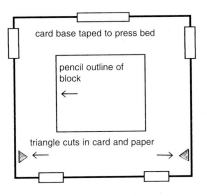

Cut-triangle proof register.

Pencil-line register

Use a thin sheet of card or paper larger than the printing paper for the baseboard. Mark an outline of the printing paper and another in the centre for the block. Place the printing paper within the outline and rule two lines at the centre of both short sides of the paper con-tinuing onto the baseboard. For editioning, match up all the sheets of printing paper with the lines on the baseboard extending the ruled line onto each sheet in turn.

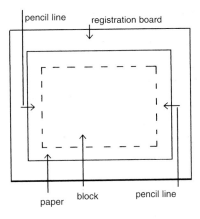

Pencil line register.

Walter Hoyle's register

A fold of stiff paper is taped to the left side of the bed. Two pencil lines are marked on the fold and matched with lines on the back of the paper.

Corner and edge register

To ensure accurate registration for deckle-edged paper, the bottom left-

hand corner must be cut to a precise right angle and a short, straight cut made along the bottom edge. Use a firm baseboard of thick card, hardboard or chipboard. Draw pencil outlines on the board indicating the permanent location for paper and block. Hold the block in position and glue down a straight-edged strip of card butted up against the bottom edge of the block. Place this strip close to the bottom right-hand corner. Then glue down two more card strips to form a right angle firmly against the bottom left-hand corner. The card strips should be thinner than the block yet sufficiently thick to keep it in place. Position the paper in the drawn outline, secure with a weight, and as before, make corner and edge card-strip registers for the bottom edge and left-hand corner. This bottom-edge strip should be positioned between the centre and the right-hand corner of the paper.

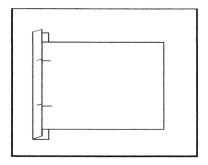

Walter Hoyle's register.

Corner and edge paper register. 'Ludo' stencil and card block.

Glue the strips down firmly. If the baseboard is chipboard or wood, staples may be used too.

On the block register

This is very similar to the Japanese *kentō* system. The paper edges should be trimmed first as before. Instead of a baseboard, the corner and edge-registration stops for the paper are located on extended borders of the block. The paper is laid face down on the block with the edges overlapping onto the extended borders. A pencil line is drawn to indicate the exact position of one of the bottom corners and nearest edge of the paper. A knife cut is made along the drawn line and the inside edge of the cut is lowered with a wide chisel so the paper can slot precisely into both recesses. (The illustration on p. 67 shows two blocks which incorporate this system.)

Free-form register

Register irregularly shaped blocks around the edges with card stops. Use pencil markers if the stops obstruct other stages of printing or print an

offset 'key block' proof onto the baseboard in the chosen position. Seal the print by sprinkling talcum powder over the wet proof, shaking off the surplus.

Ink

Until a few years ago the great majority of printmakers and college departments used only oil-based inks for relief printmaking. The drive towards healthier and safer working environments has greatly increased the use of water-based inks. Switching from one medium to another presents demanding challenges and we have to adapt our skills and sensitivities to a different feel and behaviour of ink. Commercial water-washable, glycerine-, acrylic- and vegetable-oil based inks are constantly being tested and recipes revised to improve the ink's quality and satisfy the demands of the customer. As a result there is a wide range of inks available including those which the printmaker can make in the studio from natural pigments and dyes.

Plant-based colours have been researched extensively by Phil Shaw at Middlesex University. Using preparations of water-based extracts, dry 'lake' pigments, binders, preservatives and additives, Phil has made screen, intaglio and relief printmaking inks from a range of plants that give primary colours and black. (To find out more about Phil's research contact him at: http//www.mdx.ac.uk/www/vcd/21PS/PS.html)

Water-soluble inks

Powder pigments should be firmly ground with a muller and mixed with water and gum arabic or rice paste. The colour is applied to the block with a roller, dabber, or brush in the Japanese manner. Store pigments and mixes in airtight containers.

Drawing inks, watercolours thickened with rice paste, and gouache (diluted for transparency), can be applied in the same way.

Commercially prepared artists' grade water-soluble inks, often termed water-washable, contain good pigments, are slow-drying, inclining towards a matt finish. Ask the supplier if magnesium cobalt driers should be added before printing.

Some printmaking suppliers stock excellent water washable relief inks composed of a glycerine base and a blending of oils. The ink has little odour and a good tack for rolling up. (For more information on suppliers, see p. 119.)

Rubber-based inks

These inks share a working similarity and compatibility with linseed oil-based inks. Cobalt driers may be added to increase their very slow drying properties. The inks are most suited to waterleaf or tub-sized paper.

The Pantone system and oil based inks

Industrial ink suppliers sell commercially made Pantone inks in eight standard, transparent colours. The Pantone colour-chart book is an invaluable guide for mixing and matching colour proportions.

There are excellent linseed oil-based inks stocked by all leading suppliers. Colours are transparent or opaque with the level of viscosity varying amongst products. Magnesium cobalt driers should be added if recommended. Some relief printmakers use a stiff lithographic ink which needs to be thinned with refined linseed oil.

Commercially produced letterpress and offset litho printing inks offer the cheapest range of inks but the colours are not always light fast. The inks are mostly transparent and often brilliant in colour.

Inks suitable for rolling or brushing can be made by mixing finely ground powder pigment with linseed oil. Although expensive and containing much oil, artists' oil paints may be used instead of ink.

A basic palette

The following palette provides a suitable basis for intermixing a very wide range of colours: Black, opaque white, vermilion red, mid chrome or mid cadmium yellow, alizarin crimson, burnt or raw umber, pale chrome or pale cadmium yellow, viridian green, monastral blue, ultramarine, and transparent reducing or extender medium.

Rollers (brayers)

I have about eight rollers ranging from hard to soft in 25 mm–300 mm (1 in. x 12 in.) lengths. The most versatile and durable are two medium/firm rollers made by Rollaco with dimensions: 150 mm x 50 mm (6 in. x 2 in.) and 100 mm x 50 mm (4 in. x 2 in.). They consist of primary plasticised polyurethane (which the company calls 'suprathane') and have brass frames. Rollaco make three durometer grades of polyurethane rollers: 20 Shaw which is a soft roller, 30 Shaw – medium-firm and 40 Shaw – firm. Polyurethane has a very high resistance to abrasion and chemicals in ink and solvents. The rollers have the highest efficiency of transfer for inking thin films of ink. A light dusting of talcum powder protects the roller when not in use.

Methods of inking

Tinting and testing

Oil or water-based transparent, reducing medium is the essential additive for tinting and extending the transparency of the colour. At the planning stage of proofing, small colour tests should be made first to avoid unnecessary wastage. Add only a fraction of colour to a small amount of

reducing medium and combine thoroughly. Check the degree of tint by scraping a very thin swatch onto a scrap of white paper. If the colour swatch is too weak add another minute percentage of colour to the medium and make another swatch beside the first. When you have found the desired tint, mix up a larger quantity in equal ratio to the test mix.

Tests and swatches are made in the same way for colour blending with opaque white. Place your colour testings at the top end of the inking slab so that there is a clear space for rolling out ink. Some oil-based inks are very stiff and may need loosening with a small quantity of boiled linseed

'KJK-18' by Juergen Strunck, USA. Ink on four triangular sheets of Japanese fibre, mounted in square format, 6 mm apart, on black Arches paper. 106.6 cm x 106.6 cm (42 in. x 42 in.) 1997.
Juergen writes, 'I used a large litho plate glued to a base of masonite board. There were two inking runs for 'KJK-18' with stencils/masks attached to the paper in the second run. The print is run through again with newsprint on top to reduce the excess of ink. I applied the ink with a cone-shaped roller of my own design blending multiple colours in each inking. The cone-shaped design allows for the circular distribution of colours. When the inking was completed I printed the plate on an intaglio press.'

oil to maintain good rolling and inking-up. Add a few drops of oil at a time to the ink working it in very thoroughly with a flexible palette knife until the desired consistency is reached. If the ink is thinned too much the roller will slip on the slab. Any excess of oil will seep from the contours of printed colour areas leaving a yellow stain on the reverse of the paper.

1. The basic rolling-up procedure

Spread out a strip of ink no wider than the roller at the top end of the slab. Pick up a small quantity of ink on the roller and roll out to a minimum length of 25 cm (10 in.). Lift the roller, allowing it to revolve in the air, before re-rolling back to the top. The lift and roll action distributes an even layer of ink. The ink should 'hiss like the rasp of a cow's tongue' to indicate a light ink loading. If it sounds like car tyres running over wet tarmac on a hot day, there is too much ink and any excess should be scraped back to the strip at the top.

Roll the first application of ink onto the block and return to the slab to reload the roller and repeat the action as before. As the ink on the slab becomes sparse, collect more ink from the strip at the top. Remember to 'lift and roll, lift and roll', always keeping the roller in a straight line.

The porous surface of a new woodblock will soak up the most ink. Consider carefully the direction of the roll. Rolling parallel with cuts on the block will deposit less ink in the recesses than crossing over them.

Small and soft rollers make more contact with recessed areas than large rollers. Hard rollers preserve fine surface detail and textures.

'Fold' by Peter Ford, UK. A series of woodcut variants.16.5 cm x 79 cm (6½ in. x 31 in.) 1998.

'Fold', which anticipated further works in book form, originated from an earlier woodcut produced from a single piece of plywood. After cutting and collaging together elements from the initial print, Peter decided to cut the matrix into three sections using each for a different work. Etching ink was applied with a cloth and after wiping, lithographic ink was rolled across the uncut surfaces. Some of this surface colour was wiped off with a soft rag before printing. The colour variants of relief and intaglio impressions were printed on dampened Somerset paper (300gsm) using an etching press. The final elements of 'Fold' were joined together (using conservation tape reinforced with acid-free glue) in raised, zig-zag formation.

2. Two-colour inking

This can be made from the block using a soft and a hard roller. The paper should be heavy, damp and pliable. Using a stiff ink, roll the first colour into the lower recesses with a soft roller and pull a print using soft packing. Clean the block and roll a more viscous ink over the surface with a hard roller. Print the second colour with harder packing such as card. (Other colours may be brushed into very deep recesses and printed with the first colour.)

3. 'Fade-out' colour gradation and 'rainbow rolling'

A wide roller is preferable for printing transparent or opaque colour graduations. Use a 25 cm or 30 cm (10 in. x 12 in.) wide roller for the following method.

Mix up three small amounts of reducing medium or opaque white containing colour additions of 80%, 30% and 5% respectively. Place a little of each mix, in identical sequence, in a row at the top of the slab about 70 mm apart. Add a small quantity of full-strength colour to the left of the 80% tint, and, depending upon choice, pure medium or opaque white to the right of the 5% mix. Spread each amount slightly towards each other cleaning the palette knife each time.

Lightly charge up the roller with each degree of colour and roll them down the slab. Keep the roller in a straight line until the ink is evenly distributed and then, continuing to lift and roll, gradually move the roller from side to side merging the strips together.

The resulting strip should reveal the full colour at one end evenly reducing to a transparent or opaque white at the other end. The technique can be employed with any colour combination to produce beautiful 'rainbow' colour effects. The block must be inked-up carefully to avoid unfortunate colour collisions.

4. Sheath printing – a technique devised by Michael Rothenstein

The dramatic appearance of a deeply cut relief surface or a powerful, open wood grain can be stilled to a gentle softness with a sheath of thin plastic overlay. The

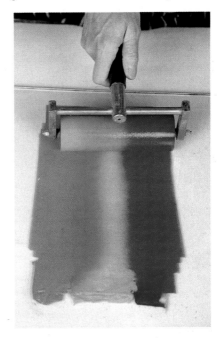

'Rainbow' rolling. See p. 87 for 'Fade out' rolling.

plastic must be suitably thin to show a subtle variation of the drama underneath.

Cut the plastic so the edges hang a little way over the sides of the block. Roll out the ink on the slab with a medium/soft roller charged with sufficient ink for the following stage. Place the plastic sheath on the slab and roll a continuously even, thin layer of ink onto the top surface. The ink on the slab prevents the plastic from wrapping around the roller. Lift the plastic sheath with the aid of a scalpel blade and lay it over the block with the inked side facing upwards. Lay paper on top to print.

The impression will vary according to the packing and pressure of the press. Use soft packing, trying out a wad of newspaper, blankets or foam rubber. Afterwards, a hard roller and firm packing are used to overprint the open block onto the sheath-printed image so the contrasts of the two processes converge within the unity of the print.

Checklist for proofing

1. Brush and wipe any cut shavings from the block.

2. Seal the block if necessary with shellac and leave to dry thoroughly.

3. Make accurate registration guides as necessary.

4. Make colour tests and swatches for all the blocks.

5. Explore the potential of different types of packing and qualities of pressure.

6. Mix light inks first, adding darker colours as necessary. Spray mixed ink on the slab with an antioxidant if you are not using it immediately. Preserve unused ink in acetate envelopes.

7. Use a good-quality proofing paper, making final proofs on editioning paper.

8. If wished, leave the proofing ink on the block to seal the grain. When the ink is dry, smooth the block with fine sandpaper and wipe with a moist cloth.

Checklist for editioning

1. Cut and stack dry editioning paper in a clean area, or dampen the paper with a sponge or spray several hours before editioning. Interleave the sheets between newsprint and seal within a plastic sheet.

2. Locate a space for hanging or racking prints made on dry paper or for stacking prints on damp paper. A blow air-heater placed near the racks swiftens the drying process of completed prints. When laying a print in a horizontal racking system leave one paper edge slightly overhanging

the front edge of the shelf to enable easy removal. Many suppliers stock high-quality shelving systems of varying sizes.

3. Keep hands clean and use folded paper grips to hold all paper.

4. Maintain a consistent order and rhythm of inking, packing and pressure.

5. Check that dampened paper remains moist.

6. After each printing, place weights on the paper whilst it remains on the block. Lift up the paper and examine the print. If details need to be strengthened by hand burnishing, place a scrap of newsprint between the *baren* or spoon to protect the paper. You may have to roll a little more ink on these areas before burnishing.

7. Using the paper grips, raise both sides of the paper at the same time to remove the print from the block.

8. If the paper is damp and more colours are to be printed, interleave the prints between moist newsprint and cover with a sheet of plastic.

9. When the last colour has been printed on damp paper leave the paper in open air for a short time before stacking with acid-free tissue paper between each sheet. If the edition is large, place acid-free white boards at intervals between the sheets. Put a heavy board on top to weigh down until dry.

Tips

1. This is a simple way to avoid scuffing the edge of the paper with ink when lowering it onto the block: before lowering the paper, place a narrow strip of newsprint along the nearside edge of the block. After registering the paper, put two weights on top and lift up the edge to remove the strip before proceeding to pack and print.

2. A few drops of disinfectant added to the water will preserve paper for a few days.

3. If a print is loaded with too much ink return it to the block with a sheet of newsprint placed in between. Run the print through the press to offset the excess ink onto the newsprint. This process can be repeated several times (using fresh newsprint for each pull) until the desired weight of print is achieved.

4. Keep a written record of your colour mixes and press packing for editioning and save colour swatches and any leftover oil-based ink in air-tight plastic envelopes made from acetate offcuts and tape. Any swatches left on the inking slab should be lightly sprayed with an antioxidiser.

Cleaning up

1. Wear barrier cream and rubber gloves.

2. Use recyclable rags, newspaper and old phone directories for cleaning knives and rollers.

3. For cleaning oil-based inks from blocks, the inking slab, rollers and knives use vegetable oil or 'Vegeol'. Clean the rollers as soon as printing is completed to avoid damage caused by dried ink. Sprinkle cleaning oil on a newspaper sheet and roll the roller across it to remove most of the ink. Finish off with a soft rag and more oil.

4. Use a minimum of cleaning oil on wood blocks rubbing off any excess oil with a dry rag.

5. Wash water-based inks from all working materials in warm water using a biodegradable soap.

6. Hang up rollers, tidy up all tools and press packing, keep the extractor fan on, and switch off all other power points before leaving the studio in a state of readiness for another day's work.

Further detailed guidance on basic practice is described by Jane Stobart in *Printmaking for Beginners,* a book in this series by A & C Black.

Paper

'For me, paper is a God with two backs on which he carries all human knowledge.' Omar Rayo.

Paper was invented in AD105 by Tsai Lun who is regarded by the Chinese as the God of paper-making.

I encourage students to explore all kinds of paper and indeed go beyond the logic of this accepted material to print on other surfaces such as card, plastic, hardboard, fabric and metal foil. This way we unlock the perception to new possibilities, conserve nature's resources and gain a greater appreciation for the richness, diversity and creative potential which paper provides.

There are a growing number of printmakers who make their own paper thereby ensuring a homogeneity of materials and process in which every ingredient is of their own construction.

Many commercially produced papers are suitable or made specifically for relief printmaking. The nature of the block, manner of printing, type of ink and the desired image determine the choice of paper. Decisions on printing with dry or damp paper, with press or *baren* are essential factors to consider.

The best paper for relief printmaking is hand-made – of pure materials, strong and unsized, (waterleaf) or lightly (soft) sized to give added

strength to the fibres. Most relief printmakers choose either hand-made or mould-made papers which are also made of pure materials. With the exception of acid-free wood-based papers, machine-made paper consists of impure materials and can be reserved for economical proofing and experimentation.

Japanese hand-made papers are used for watercolour and oil-based block printing. The paper is either unsized or lightly sized. Imitation Japanese papers are useful for proofing. *Torinoko* and *Hosho* are popular papers. Intaglio Printmakers (in the UK) sell *Hosho* in sketch-book format. *Okawara* is available in huge sheet sizes for large-scale block printing.

Hand-made paper is recognisable by its four (ragged) deckle edges. Cylinder mould-made paper has two deckle edges along the length sides. A false deckle can replace the sharp edges of machine-made paper by placing a heavy ruler on the paper and carefully tearing off a ragged strip parallel to the cut edge. Stanley Jones often uses a kitchen grater along a pile of sheets.

The printmaking studio should contain a good stock of newsprint, acid-free tissue paper, white cartridge paper for proofing and rigid, acid-free card for stacking and editioning.

Store all papers in plan chest drawers in a dry, dust-free environment. Interleave stored prints with acid-free tissue paper to protect the surfaces.

Listed below are high-quality papers which are widely available. There are many other useful Indian, Nepalese and Thai papers available at major paper stockists. The suppliers' names and addresses can be found in the Suppliers List on p. 119.

Name	Size(mm)	Furnish	Manufacture	Comments
Arches Velin	many	100% rag	French, mould-made	off white and cream
Arches Ingres	650 x 1,000	75% rag	French, mould-made	white and cream
Arches 88	560 x 760	100% rag	French, mould-made waterleaf	white, available in rolls
BFK Rives	many	100% rag	French, mould-made	white
Circle	530 x 760	25% rag and alpha cellulose	British, mould-made	white, excellent for book work and engraving
Fabriano Artistico	560 x 760	100% rag	Italian, mould-made	white
Fabriano Esportazione	560 x 760	100% rag	Italian, mould-made	white
Fabriano Murillo	700 x 1,000	15% rag	Italian, machine-made	colours, white and black
Fabriano Rosaspina	700 x 1,000	40% rag	Italian, mould-made	white and ivory very popular for relief work

Name	Size(mm)	Furnish	Manufacture	Comments
Fabriano Tiepolo	560 x 760	100% rag	Italian, mould-made	white
Heritage	many	wood, also made with 100% rag	British, machine-made	white
Hosho	different sheet sizes	part-kozo	Japanese hand-made, laid	waterleaf, white
JPP Mould-made	570 x 760/ 760 x 1020	100% rag	British, mould-made	white
Kanoko	1,000 x 660	90% wood pulp, acid-free	Japanese, hand-made	off white/ natural, good for wood engraving
Kawasaki	945 x 680	kozo and acid-free wood pulp	Japanese, hand-made	pale/off white
Kochi	510 x 660	kozo and acid-free wood pulp	Japanese, hand-made	waterleaf natural colour
Lana Gravure (1,590 edition)	560 x 760	100% rag	French, mould-made	off white
Lana Royal Crown	560 x 760	100% rag	French, mould-made	natural white
Moulin du Gue	570 x 760	100% rag	French, mould-made	white
Okawara	1,880 x 915	50% kozo 50% hemp	Japanese, machine-made	off white
Sekishu Shi	610 x 990	kozo and acid-free wood pulp	Japanese, hand-made	very thin, natural and white
Shoji	930 x 630	kozo and acid-free wood pulp	Japanese, hand-made	off-white
Somerset	560 x 760 760 x 1,120 & rolls	100% rag	Britain, mould-made	white, buff, grey and black
Saunders Waterford	560 x 760 660 x 101.6 & rolls	100% rag	British mould-made	white
Torinoko	510 x 660	kozo and acid-free wood pulp	Japanese, hand-made	heavy, soft, absorbent white
Whatman Printmaking	560 x 760	100% rag	British, mould-made	white

These details were provided by paper distributors in the UK.

Chapter 4

BLOCK CONSTRUCTION AND ADVANCED PRINTING METHODS

■ This chapter explains numerous methods of block making and printing accompanied by many descriptions of individual approaches to the standard practice.

Preparing the plank and plywood block

Surface cuts will show up most clearly in the print if the block is planed and smoothed first. After sanding with a fine-grade paper, two thin coats of shellac can be brushed on the block to bind the wood grain together. A final sanding with flour-grade paper leaves a very smooth surface which is ready for the drawing and cutting. Alternatively, if oil-based inks are used, after the first proof has been printed the ink can be left on the block to dry and then sanded to produce a smooth, silky finish. In this way, the block is less absorbent, inking is easier and cuts will be clearly defined in the prints.

Preparing the lino block

The lino block should be flat. If curved, place the block face upwards on a hot plate and heat to a warm temperature. Bend the lino gently in the opposite direction to the curl until it straightens out. Remove the block from the heat and immediately place it under heavy boards until flattened. Alternatively, provide a rigid base for the block by gluing it onto a sheet of hardboard or thin plywood. Cutting old, hard lino is made easier by softening it, face up, on the hot plate for a few moments.

Smoothing the lino with wet and dry sandpaper and water will remove unwanted texture and grease from the surface. Methylated spirits (denatured alcohol) or a mild screenprinting powder degreaser mixed to a paste in water removes grease so drawings will take hold. The hessian backing must not get wet because it will shrink and warp the block. Some printmakers paint white or black emulsion on the lino, sanding lightly

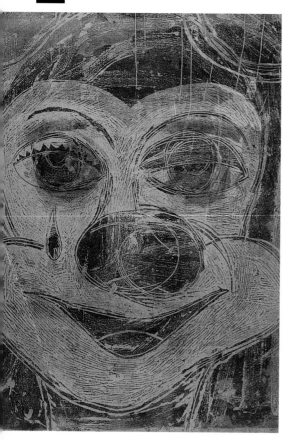

'Metamorphosis of Me into Minnie'
152.5 cm x 122 cm (60 in. x 48 in.) 1998.
© Elaine Kowalsky 2000. All rights
reserved, DACS. This part-relief, part-
monoprint is press printed and pro-
duced from four blocks, the initial
block cut with hand tools. Elaine uses a
high proportion of transparent base in
her inks, placing paper stencils and
masks on the blocks throughout the
printing process in order to filter vary-
ing degrees of colour intensity through
the layers. Monoprinting is the natural
territory for the painter disquieted by
the intervention of a printing press and
technical processes. Elaine's prints dis-
pel the painter's concern that printmak-
ing denies the spontaneous expression
of a freehand brush mark. Elaine
applies the same vigorous energy to
cutting lino as she does to brushing
and rolling ink straight onto the block.

afterwards, so the drawing and
cuts are clearly visible. If the block
remains greasy add a few drops of
liquid detergent to the paint.

Transferring the original image to a wood or lino block

There are several transfer methods:

1. A traditional way is to make
 the drawing on thin, fine paper
 with waterproof black ink. Coat
 the drawing side of the paper
 with gum and glue it down
 onto the block. When it has
 dried, the paper is dampened
 and gently rubbed off with the
 finger bit by bit, leaving the ink
 design in reverse on the block.
 Alternatively, once gummed
 down, make the paper trans-
 parent by rubbing all over with
 oil. Follow the outline of the
 drawing and cut right through
 the paper to incise the design
 on the block beneath.

2. The drawing can be made
 directly onto the surface of a
 block. Pencil, ballpoint pen,
 pastel, chalk, and brushes with
 ink or paint all work well.
 This direct approach keeps the
 marks lively and spontaneous.

3. Make a tracing of the original
 drawing and lay this face down
 on the block. Fix the paper in
 place with sticky tape and
 retrace the drawing on the
 upper reverse side. Avoid heavy
 pressure when drawing on the
 block as a pencil point can
 indent a soft surface. To transfer
 a very clear drawing place

carbon-coated copy paper between the tracing paper and the block. Before inking, any residue of carbon can be wiped away with methylated spirits (denatured alcohol) and a rag.

4. Lazertran is a commercial water slide paper that allows the transfer of full-colour images and drawings onto almost any surface including wood, metal, plastic, lino and canvas. Black and white photocopied images can be transferred via Lazertran paper to metal plates for relief etching with ferric chloride and to lino blocks for caustic soda etching. Use protective gloves and a fume-protection mask.

5. 'Quick Off' is a commercial product for transferring photocopies and laser images to metal plates for relief and intaglio etching. Use protective gloves and a fume-protection mask.

6a With Sue Anne Bottomley's 'Stenocut' process, fresh newspaper images and pencil drawings can be transferred easily to the thin rubber plate surface without a solvent. Simply burnish the back of the paper with a spoon or run it through a press under light pressure.

6b Sue Ann Bottomley uses oil of wintergreen (methyl salicylate) to transfer a photo-copied image to the surface of a 'Stenocut' plate. The oil, which some pharmacists stock, has a strong, but not unpleasant odour. Gloves should be worn and the studio well ventilated, or the process done out of doors. Place the recent photocopy face down on the plate and rub the back of the paper with a small amount of the oil on a cloth or paper towel. After lifting the paper off the surface leave the paper and the plate to dry outside before cutting. The photo image is then ready to be carved.

7. The image of 'The Ship' was screen-printed onto the block. Frank Tinsley used an old, scratched drawing board for this print. He added no further cuts of his own to the close-grained wood. 'I wanted to have an image submerged in the wood,' he said. Frank screen-printed the ship (a halftone photo stencil made from a magazine cutting) onto the block first and left the screen ink to dry. Ink (in metaphor the ship) filled the grain settling as a very low relief, smooth plateau

'The Ship' by Frank Tinsley, UK. Wood and halftone screen stencil, 76 cm x 56 cm (30 in. x 22 in.) 1997.

fractionally higher than the surrounding surface. Using a hard roller, Frank inked-up the block with a blending of 40% black ink and 60% transparent medium. There is a fine integration of technique and poetic concept as the fleeting form of the ship just skims across our vision. 300gsm dry Fabriano paper and crisp foam board for press packing assisted in conveying the subtle qualities Frank sought.

8. The block must be very smooth for a photographic transfer. Waterproof it by coating it two or three times with liquid egg-white, smearing each coat across the block with your fingertips to eliminate air bubbles and waiting until one coat is completely dry before applying the next. Mix a little zinc oxide for whiteness into the final coat, and when dry, smooth it down very gently with the finest sandpaper. Pour a proprietary brand of photographic emulsion over the surface of the block and allow the excess to run off. As soon as the emulsion dries it becomes light sensitive, so it is essential to work in the dark. Put the photographic negative on the block once the emulsion has dried, then expose it to a light source and develop according to the manufacturer's instructions. The resulting image will provide a guide to cutting.

Single block printing with stencils and masks

At first glance single block printing often appears to be the simplest method of working yet there are many approaches to cutting, inking and printing.

Whatever the choice of materials and pressure, the professional printmaker knows instinctively that every action between the first cut and the final removal of the paper has a determining effect upon the resulting print. One of the easiest ways of extending the potential of a single block is to use stencils and masks.

1. Several colours can be added to the single block by laying down cut-out, inked acetate shapes on the inked surface. Similarly, an uninked acetate or thin paper shape can be used to mask off an area of the block. The masked area can be printed at a later stage in a different colour from another block or stencil.

2. Thin paper or acetate stencils are used to make multicolour prints from a single block. Prints were made from the 'Ludo' cardblock in this way (see p. 50). First, a set of stencils were made by taking several prints from the block on sheets of newsprint. Then using these prints as guides, openings were cut out in each one to make a stencil for each colour to be printed through. Slots were cut at the corners of each stencil to locate the matching position on the inked block. The printing paper was positioned on top using the corner and edge registers.

Numerous layers of colours were built up in a variety of formats for a series of variable prints.

3. Additional colours can be stencilled directly onto a print using a cut-out opening in an acetate sheet. Practise first on a scrap of paper. Lay the print face up on a firm, smooth surface and place the stencil opening over the section of the print to be inked. Holding the stencil firmly with one hand, roll the ink onto the paper through the stencil opening. An inked rag or a dabber made of cotton bound in fabric or gauze can be used instead. If the stencil is thick it may be necessary to make the stencil opening a fraction larger than the area to be printed. 'Loose' ink is used with a roller so that it does not stick to the paper.

The reduction block

The process involves a sequence of printing and cutting from one block to produce an edition of multiple colour prints. Usually an edition is made this way by a succession of over-printings, commencing with the lightest colour and finishing with the darkest. After the first colour has been inked over the entire block and the required number of registered prints have been taken, the sections of the block which correspond to that initial colour are cut away. Then the next colour is printed over the first and again the relevant areas are removed. Inking, printing and cutting continue in this pattern until all the colours have been printed. After the final printing the much-reduced block can be thrown away.

'Centrosome' by Ann Westley. Reduction linocut and screen print, 71.5 cm x 54 cm (28 in. x 21¼ in.) 1992.

The subject of *'Centrosome'* concerns the technological modification of living forms. There is a relationship between genetic manipulation and the inheritance of information that builds up in the print as one generation of colour is superimposed upon another. The central reduction block (reds and black) was slotted into the main (yellows) reduction block so that both could be inked easily and, at some stages, printed separately. The bottom blue block and caustic etched block at the top were printed next. Other small blocks, like the circle at the top, were added last. Finally, the linear figures with the fish were screenprinted through a photo stencil onto the base of the image.

'Twenty-five Swimmers' by Dale Devereux Barker, UK. Linocut with six separate printings, 30 cm x 30 cm (11¾ in. x 11¾ in.) 300gsm smooth Somerset, 1997.

Dale Devereux Barker teases the conventional routine of the reduction process with chance interventions of unrelated blocks. Printmaking with an enviable freedom, he joyfully disdains any notion of editioning. Favourite old blocks, cut or etched, reappear in different guises in many prints. Often they are very small but carry great orchestrations of fascinating textures and patterns. Dale juxtaposes dazzling overlays of brilliant colours, using lots of transparent base in his oil-based ink to let the luminosity of under-printed forms radiate through the top colours.

'Bluecoat' by Magnus Irvin, UK. Woodcut, ed. 2, 218 cm x 116 cm (85¾ in. x 45½ in.) 160gsm Lana Aquarelle Grain Satin, a thin paper for hand burnishing, 1997.

Magnus prints large blocks like this one on the studio floor placing wooden corner and edge registration blocks alongside each block to locate the paper. When the paper is in position he removes the registers, puts weights on the paper and starts burnishing. He used the reduction block process for this massive print of a friend. 'He is a big chap so I decided to make him even bigger! It took many blocks (different types of plywood with broad and close grains) to make him. Many of the blocks were cut to shape and reduced along the way. By the end, most of the blocks were destroyed. There are probably more than 40 stages in the printing. Each stage was hand-burnished using hand-held wooden blocks which I shaped myself. In some places there is only a single, transparent layer of ink, other areas carry five to six opaque layers.'

Sometimes during the reduction process there can be a sense of being confined to a linear, systematic order which prompts the thought, 'There's no going back once I've started this!' Instead of being restricted to a regime of identical prints, change the colours as you progress so there is a rewarding diversity of results at the finish. Other blocks, masks and stencils can be introduced into the scheme too, as happened in 'Centrosome'.

Multiple block printing

The key block system

This is the simplest system for making multiple colour blocks. The key block contains all the elements of the design and can be used to print the strongest defining colour. Further blocks are made for additional colours. Using the key block, trace the individual colour sections of the design onto separate blocks marking the precise location of the key registration each time. Cut and print the colours first and over-print the key block last.

Alternatively, to enable extremely accurate alignment, offset a print from the key block onto each colour block. First make a print from the key block on non-absorbent paper or clear acetate. Lay the wet print face down on the second block. If you use paper, cut out corner slots around the print to assist accurate alignment with the block. Run through the press under firm pressure. Remove the print and leave the offset print to dry.

A print on transparent acetate is made from the key block of 'Flying Jump', a 35 cm x 40 cm (13¾ in. x 15¾ in.) ply-wood block print by the author, and is transferred to a second block to locate the exact positioning of colours and surface areas to be cut. In this case the second block was cut into jigsaw pieces, each of which were inked in individual colours and reassembled before printing in one pull.

The left-hand block shows the offset print of 'Flying Jump', a childrens' book image, waiting to be cut. The right-hand block has been jigsaw cut and stained from previous printing. Note the extensions of identical corner and edge registration on both blocks.

'Swimmer' by Frans Wesselman, UK. Etching with woodcut, 30.5 cm x 30.5 cm (12 in. x 12 in.) 1997. Using the offset method Frans combines relief and intaglio surfaces for printing. Frans writes, 'While still wet, a proof from the etched plate was transferred to a sheet of 2 mm plywood. Using a fretsaw, I cut the block into jigsaw sections. After working the surfaces with hand tools, the pieces were inked separately, reassembled and printed. When the ink was dry, the paper was dampened and the initial etched plate was printed over the top.'

'Remember Birds?' by Ruth Burgess, Aus. Multiple woodcut, 90 cm x 70 cm (35½ in. x 27½ in.) 1993.

If you wish to begin cutting immediately, a smudged print can be avoided by sprinkling talcum powder over the block. Shake off the excess talc so that the image is visible and the block ready to cut.

Ruth Burgess is an Australian artist whose work and spiritual beliefs are greatly inspired by her close cultural connections with China. Chinese traditions of depicting birds and landscape harmonise with her love of forests and the wood she chooses for her blocks. For her print, *Remember Birds?* Ruth provides us with a clear description of her procedure for multiple block printing:

1. This image was printed by hand with a *baren* and wooden spoon onto a Chinese paper more commonly made for painting.

2. First I printed a grained block in Ultramarine mixing artist's oil paint in a transparent printing-ink base. The use of oil paint enables me to have any range of painterly colours I choose.

3. The second block of wood is a freely cut image and is printed in Indian Red.

4. I cut another block with fine carving to create transparent layers printing this in Cerulean Blue.

5. Wet on wet, I printed the block with the top image of birds in a white linseed oil-based ink.

Jigsaw multiple blocks

Sandy Sykes crashes all the barriers of convention. You cannot nail her work into any division or process. She uses many techniques and any tool that serves her purpose. Sandy's wit, satire and encyclopaedic grip on social and political affairs, ancient myths, literature and politics shoot at ballistic rate down the shaft of chisel and spin off the burr of electrical engraver. She uses assortments of wood, lino and metal plates, vigorously cutting complexities of multiple blocks, jigsawing and inking to assemble many varied forms on top of each other. Obscure words, blatant messages, figures, cars, real and mythical beasts all collide on huge sheets of light-weight Indian paper that is invariably too big for her press. Hand burnishing with wooden spoon and *baren* provides the immediacy of physical involvement and variations of pressure which accord with the intensity of her experience. There are times when the press (she uses relief and intaglio) might sever that vital connection.

Another printmaker, Jean Lodge, writes 'I never know how many blocks will be necessary when I begin. I make a monochrome drawing first but the prints look quite different. There is much proofing in between and the final image is always a surprise. I use a cylinder press and nearly always cut one block for each colour. However, in *Ophelia Lives* I did apply two

different colours to the same birch plywood block – the two areas (the green of eyes and rose of cheeks and mouth) being well separated. Also I jigsawed out shapes that could be inked in distinct colours and then reassembled on the bed of the press for printing. This was the case with the gold background stripes and the words.' (See p. 47 for registering jigsaw blocks on an etching press.)

Printing wood engravings

A wood-engraved block can be printed by hand or press. Commercially prepared blocks are cut to the standard type height of 23.3 mm (0.918 ins.) the necessary height for printing on a cylinder press. If necessary, thin or irregular blocks can be built up from beneath with thin sheets of paper or card to 'make ready' to type height. Barry Woodcock prints most of his engravings on a small screw-top press taping a few sheets of newsprint packing to the underside of the top platen. He uses a thin application of commercial offset litho ink or extra stiff ink which he rolls lightly in different directions across the block with a firm roller. His engravings are press-printed on A4 100–120gsm smooth laser copy paper. When printing by hand he uses thin, tough Japanese mulberry paper and places a protecting sheet of thin, transparent acetate between the paper and his burnishing spoon.

n.b. Store blocks standing apart on their sides in a dry place in an atmosphere of even temperature and humidity, away from sunlight.

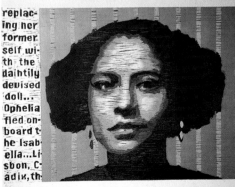

'Ophelia Lives' by Jean Lodge, UK. Woodcut, 50 cm x 82 cm (19¾ in. x 32¼ in.) 1995.
Jean Lodge emigrated to Europe (Paris and Oxford) from Ohio in the 1960's. Her eclectic and migratory spirit accords with her chosen subjects and printmaking procedure. 'I am always interested in change and metamor-phosis... Shakespeare's Ophelia sews together a life-size doll, a facsimile of herself, and then sails for Elsinore... she becomes a different person... moving into the unknown... these are areas I enjoy exploring.'

Opposite: 'Staircase to Heaven' by Sandy Sykes, UK. Multiple wood block, 142 cm x 170 cm (56 in. x 67 in.) 1997.
Sandy has used oil-based inks of varying viscosities. The differences of motifs from diversely cut and printed blocks dissolve in the layering of opaque and transparent inks.

'Building the Viale Foro Imperiale' by Anne Desmet, UK. Wood engraving, linocut and collage on gessoed panel, 12 cm x 30.5 cm (4¾ in. x 12 in.) ed. 1,1996.
Anne Desmet extends traditional wood engraving into mixed media. She has developed methods of collage and assemblage which synchronise with her subjects: fragmentations of historic architecture and urban landscape. Her print combines elements of wood engraving and linocut. As our present-day environment contains many remains of the past, so Anne takes fragmented images through sequences of transformation in prints and collage. This print marked a new series for Anne where the paper elements of collage are adhered to painted, gessoed wood panels. She makes frequent use of chine collé. Lightweight Japanese papers, adhered to the paper with rice paste at the time of printing, are excellent for chine collé.

Fabric printing blocks

Select smooth, closely woven fabrics for the clearest prints. Wash and iron the fabric first to remove any finish which may impair the printing.

Mount any blocks that are thinner than 2.5 cm (1 in.) so they are easy to handle. A table with a padded surface is used for professional printing or a large board can be covered with several layers of blankets and a top sheet of plastic with the edges taped down underneath.

In printing, the inked block is inverted onto the fabric and pressure applied with a mallet to the reverse side. Chalk or removable marks are drawn on the fabric to indicate the registration for repeat printing. For multicolour registration two or more pins are embedded into the edge of the design in matching positions on each block. In over-printing, the pins are matched to marks made from the previous blocks.

Commercially available oil-based fabric printing inks, similar to those used on paper, are applied with a roller to the block. Fabric printing dyes, sold in jars or bottles, are spread onto a pad of felt or folded cloth and the block is pressed onto the pad to charge it with colour. The colours are fixed by heating, usually with an iron, or by applying a fixing agent supplied by the manufacturers. The amount of colour picked up by the block can be increased by rolling a thin coat of glue onto the block and dusting it with flocking powder (powdered wool). When the glue is dry the excess flocking can be brushed away.

Metal plates

Flat sheets of scrap metal can be used in any shape or form as long as the selected section is no thicker than the tolerance of the press. Remove any sharp projections such as nails or jagged edges to protect the press and paper from damage. (See section on proofing.) Before inking, any rust and dirt should be removed with a wire brush. Sandpapering and polishing may be necessary if you want a smooth surface. Remove grease with a non-toxic de-greasing agent before inking.

Combined blocks using etched relief plates

Here are two examples of prints where I used etched plates in combination with woodblocks. As a sculptor I find much pleasure in assembling plates and blocks that share many of the characteristics of low-relief sculpture.

For *Go Cart Rider* I used a wire brush to pick up the wood grain in the pale background. The main block is Indonesian plywood into which slots the central ply and joined hardboard sections. Four acetate stencils are placed on the hardboard circles and three mild steel plates, cut on a bandsaw, are laid on top. There is a small amount of etching on these plates and the edges have been thoroughly bevelled to avoid any paper tear. After each part has been inked and put in place, damp (heavy Heritage) paper is laid on top and printing done in one pull. Lots of soft packing of old blotting paper is used to enable the printing paper to penetrate the levels of deep relief. I place heavy weights on the paper and check the print carefully before final removal from the blocks. Any areas that need additional printing, especially edges of plates, are hand burnished with a wooden spoon. When burnishing, I lay a scrap of newsprint on the back of the paper to avoid making unwanted spoon marks. The paper contracts as it dries so the work has to be done swiftly to avoid 'double imagery'.

'Go Cart Rider' by Ann Westley. Wood-block with hardboard, acetate and etched metal plates.

'Go Cart Rider' by Ann Westley. Woodcut, hardboard, acetate and etched metal plates, 95 cm x 60 cm (37½ in. x 23½ in.) 1983.

BLOCK CONSTRUCTION AND ADVANCED PRINTING METHODS

*'On The Lid of an Engine' by Ann
Westley. Woodblock with etched metal
plate inserts.*

*'On the Lid of an Engine' by Ann
Westley. Woodcut and etched metal
plates, 76 cm x 120 cm (30 in. x 47¼ in.)
Heritage paper, 1984.*

The combined blocks of *On the Lid of an Engine* are too big for my
press so the print is hand burnished. The main block is birch plywood and
has been cut using a jigsaw cutter with marks made from gouges, knives, a
surgical scalpel, a rotary sander and wire-brush attachments on an electric
drill. The features of horse's skull, helmet, arm and wheel are taken from
etched steel plates. These slot into the top layer of ply which I chiselled out
so that the surface level of the plates flushes with the surrounding wood.
Block and plates are inked separately before assembling. I like the delicate
texture which the etched surfaces provide so use a hard roller to maintain
a light surface-inking over these areas. Any unwanted deposits of ink are
wiped away with a small rag or cotton buds. When burnishing, I weigh
down the dry paper with bricks wrapped in newsprint. For registration I
mark out the paper corner and edge positions with a pencil on the bench
below the block.

Photo-etching relief blocks and plates

Making a relief plate using photopolymer film

Keith Howard of the Canadian School of Non-toxic Printmaking intro-
duced photopolymer film (employed in the printed circuit-board
industry) into photo etching a few years ago. The film (trade names
ImagOn and Photec) has a layer of emulsion which is both UV (ultra-
violet) light sensitive and acid resistant. The following brief
account of the process is based upon extensive research carried out by
Keith Howard and Edinburgh Printmakers:

1. The photopolymer film is laminated onto the printing surface which
 can be metal plate or other materials such as plastic or hardboard.

2. A photographic or autographic image on translucent drafting film is
 placed face down on the laminated film and the plate contacted in a UV
 exposure unit. Alternatively, direct stencil materials such as low-relief

textured objects, fabrics, leaves and plants may be laid on the film. Areas of the film exposed to UV light are hardened and the soft areas are washed away in a safe, inexpensive alkaline developer.

To obtain a relief etched print a negative film image is used so that after processing all line and tonal areas remain raised and the background is lowered. Artwork can be contact-printed in the darkroom or reversed out using a photocopier.

3. After rinsing in cold water, the plate is dried and the emulsion is hardened again by a long exposure to UV light for which sunlight works well. At this stage the resist is sufficiently hard for immediate intaglio or relief printing. Further contrasts of etched and relief surfaces on metal plates can be achieved by a final biting in an alkaline etch solution of ferric chloride. The photopolymer film is extremely acid resistant and even the finest detail can be subjected to lengthy biting. After etching the film is removed in an alkaline stripping solution or can remain on the plate for printing.

Similarly, relief plates can be made by adhering cut-out stencils to the laminating film using Rubylith-type masking film and carrying out the process as described.

'Head and Jacket' by Paul Coldwell, UK. Etched plate and woodcut, 60 cm x 42 cm (23½ in. x 16½ in.) ed. 7, 1998. Paul uses computer and photographic processes to orchestrate a synthesis of cool technology and eloquent aesthetic. This print reflects his vision that technique must be subordinate but appropriate to the idea. Paul writes, 'As the prints become simpler, the invention becomes more exciting.' *'Head and Jacket'* was produced from a single, photo-etched plate (computer-drawn image and deeply etched pre-sensitised plate) and one birch plywood block (the head profile) individually surface-inked and relief-printed through an etching press.

'Embarkation' by Dianne Longley, Aus. Solarplate print with hand-colouring, 41 cm x 30 cm (16 in. x 11½ in.) 1995.
'Solarplate' or photopolymer plate-making is a safe and reliable process which combines the immediacy of the handmade mark with the precision of the photograph.

Photopolymer plates

The relief printing process and form of letterpress printing known as flexography was invented in the 1880s. The flexible rubber plates used in this commercial process were designed specifically for printing on paper bags and corrugated boxes. The photopolymer plates and printing procedures of flexography used today for printing packaging, cartons, wrappings and newspapers have been researched and creatively adapted by printmakers internationally.

In her book, *Printmaking with Photopolymer Plates*, Australian printmaker, Dianne Longley gives an excellent and very comprehensive account of the use of photopolymer plates for the artist. Dianne acknowledges American printmaker, Dan Welden, as the first artist to employ industrial photopolymer plates, to which he ascribed the term 'solarplates'.

The photopolymer plates are pre-coated, extremely safe and easy to use requiring no darkroom or acids and solvents to develop the image. The plates, which can be handled in normal room-lighting conditions, consist of the following layers (in order from top to bottom): a protective cover film which is removed before UV light contact, a UV light-sensitive photopolymer layer, an adhesive and anti-halation layer, and finally, a thin backing-sheet of steel, aluminium or flexible plastic.

In order to transfer an image to the plate the cover film is removed (using latex gloves) and a drawing or photograph on transparent film is positioned over the emulsion. A negative image is contacted for relief printing. Exposure to UV light is done either through an exposure unit or direct contact to sunlight, hence the term 'solarplate'. After exposure the emulsion is washed out in tepid water, dried and given a further exposure to harden the plate. No chemicals are employed during this process. After the plate has been exposed and the image left raised on the surface it can be reworked with knives and gouges. The plates are durable and fully compatible with traditional inks and printing processes.

In Australia plates made for industry by Torerelief (WS95), Nyloprint, Printight (KM73) and Miraclon are the most suitable for the relief printmaker. See Suppliers List on p. 119 for stockists in the UK and USA.

Heliorelief blocks

The heliorelief process, developed at Graphicstudio/The Institute for Research in Art, at the University of South Florida, provides a means to transfer photographic and autographic images to wood, stone or glass blocks using a photo-emulsion that is resistant to sand blasting. The block is blasted, creating a detailed relief surface that can be inked and printed.

To seal a wood block and retain the natural grain, apply a 50/50 blend of urethane/paint thinner. When dry, use steel wool (0000) or sand (400-

A research sample of the heliorelief process using a pine-wood block produced in the printmaking department at The West of England University, Bristol.

600). Place a reversed photo negative artwork (a maximum of 35 dpi – dots per inch – for halftone) emulsion to emulsion with Image Pro Super – a photo sensitive sand-blasting resist film on a carrier sheet – in a vacuum frame and expose. Exposed areas harden and resist blasting; unexposed areas are washed away and can be blasted. After the resist film is developed (by washing) and dried, apply a medium coat of Image Pro adhesive to the block. When the adhesive is tacky, lay the film down (emulsion to adhesive) using a squeegee to avoid wrinkles and air pockets. Burnish lightly to ensure adhesion. Allow several hours or more to bond, then peel off the carrier sheet. Place the block in a blasting cabinet and, using silicon carbide or aluminium oxide (130-220), blast to the desired depth. Remove the resist with warm water and dry thoroughly. Blasted areas can be carved, sanded and sealed with 1-2 coats of urethane to prevent ink absorbtion and to make cleaning up easier.

Ink the block with a film roller and print in a press with firm backing/packing to avoid filling the grain and for a well defined print.

For a full description of this process refer to Eric B. Vontillius in the Bibliography and to the Suppliers List on p. 119 for suppliers of Image Pro Super resist film, adhesive and resist remover.

Chapter 5

CLASSIC AND CONTEMPORARY TECHNIQUES

 ## Classic Far Eastern Processes

The genesis of religion and craft entwine. In the Far East the hand-printed wood block emerged as an expression of Buddhism. In China, a spiritual and philosophical empathy with nature's wheel of life generated a revolution of holistic paper making and printmaking processes.

Following the 'Big Bang' of Tsai Lun's invention, paper making became a key industry between AD140–87 during the reign of Emperor Han Wi-ti. Block-printed silk gauzes surviving from c. AD167 in Tomb 1, Mawang-tui, are evidence of the simultaneous existence of a flourishing silk industry. Chinese paper and printmaking techniques advanced rapidly through the centuries; by the 14th century huge wood blocks were being cut to print richly ornamented multicoloured prints.

Chinese dab printing

Earth provides the touchstone for printing. Words and images transported from rock and wood convey the very essence of nature's energy. Rubbings of ancient engraved inscriptions on stone stellae (Han Dynasty, 206BC – AD221) evolved into an early form of single-colour printing on paper called 'dab printing', a process which was adapted later to the wood block surface. By the Song dynasty (AD960–1279) the technique had developed into a high art form as dab prints (often referred to as 'ink squeezes') were taken from texts cut into flat surfaces, patterned objects, monuments on cliff faces, bronze and stone tablets. Traditional methods involved the use of water-soluble inks, mica, gold and sulphur dust and a wax polish-like material with which to dab or rub the image into the paper. Today, print-makers use many colours and stencils on blocks of carved stone, wood, plaster, deep-etched plates, including collaged blocks made up from paper, glue, card and plastic sheet.

A dab print is produced by gently tamping dampened paper into all the recesses of a relief surface and dabbing gouache, water-colour paint or water-soluble ink onto those raised areas of the paper surface. Unlike the more familiar processes of relief and intaglio printing, the 'block' to be

CLASSIC AND COMTEMPORARY TECHNIQUES

'Treasure 2, Many aspects of the Buddha's Image' by Yu Qi Hui, China.
Dab-printed woodcut using water-soluble ink, 40 cm x 55 cm (15¾ in. x 21½ in.) 1992.
Bearing direct references to the ancient stone stellae (enhanced by the
three-dimensional qualities associated with dab printing), the print embodies
historical and spiritual links fundamental to both image and technique. Yu Qi Hui
prints all the surfaces created by his cutting, building up the fine modulations
of tone and three-dimensional effects by dabbing or rubbing thinly applied
transparent layers of ink.

dab-printed is cut 'right reading' and produces a 'right reading' print rather
than reversed. As all the surfaces of the block can be printed,
including every facet of the cuts and recesses, which in regular relief
printing would be excluded, the resulting print has the three-dimensional
appearance of a low-relief sculpture. Traditionally, a 'coir' brush is used
to drive the paper into the block and a cotton ball wrapped in fabric is
used for dabbing on the colour. Further effects are achieved by rubbing,
frottage, waxing and burnishing. Rollers and brushes can also be used for
applying colour.

One of the foremost innovators of dab printing today is Yu Qi Hui,
who, until his recent retirement, was the Professor of Woodblock Printing
at the China National Academy of Fine Arts in Hang Zhou. Yu Qi Hui
visited the Printmaking Department at the University of Ulster, Belfast,
in 1998, and both he and David Barker, Senior Lecturer in Printmaking at
the University, have published detailed accounts of the techniques and
history of dab printing (see Bibliography).

Japanese woodblock printing

The first millennium explosion of Chinese inventions made global waves – surging Eastwards to Japan and Westwards to Europe along the Silk Road. In Japan towards the end of the 16th century, with a growing popularity for pictorial representations of contemporary life, a new style of prints, *ukiyo-e*, emerged to portray the social scene. *Ukiyo-e* or 'Pictures of the Floating World' included masterful observations of the Kabuki theatre and interesting events within the Yoshiwara brothel houses. Amongst the most significant artists were Moronobu, Utamaro, Hokusai and Hiroshige whose paintings of actors, courtesans, geishas, and the flora and fauna of dramatic, ethereal landscapes were transported to the general populace through the medium of the multicoloured woodblock.

In the *ukiyo-e* method an initial, original painting or drawing was made by the artist and a team of cutters and printers produced the prints. In the early 18th century, Japanese artists, lead by Suzuki Harunobu, began producing the brilliant polychrome, *nishiki-e* block prints or 'Brocade Pictures', named after the elegant silk garments worn by the rich merchant classes.

Most contemporary printmakers have rejected the lavish *ukiyo-e* style, a printing procedure which removes the artist from the full creative process. Instead they prefer the total personal involvement and experimentation of the *sosaku hanga* or 'creative print'. Yet the influence of *ukiyo-e* endures as part of a time-honoured allegiance to the traditions of preceding centuries. Through upholding the block-cutting and hand-printing techniques of the past, the progressive Japanese printmaker embraces the duality of their 20th-century culture.

The Japanese method of wood-block printing shares the same tactile, sensual qualities which characterise Chinese dab printing. There are similar or identical materials and recipes, the exclusion of a printing press and the print-maker's personal devotion to traditional preparations of colours, paste, *baren* and handmade paper. There is the balanced harmony of

'Sophie's Jug' by Robert Young, Canada. Hand-burnished Japanese woodblock, 40 cm x 45 cm (15¾ in. x 17¾ in.) 1989. Robert handed his original watercolour study and drawing to printers at the Sawai Atelier in Vancouver who cut and printed the blocks using the traditional *ukiyo-e* process.

'Northern Lights' by Noboru Sawai, Canada. Japanese woodcut and etching, 58 cm x 68 cm (22¾ in. x 26¾ in.) 1994.

Noboru runs the Sawai Atelier in Vancouver. He has a consummate knowledge of traditional Japanese processes. He writes, 'I have researched and produced my own paper, *Kashiki Etching SE*. SE stands for Sawai and Ebuchi who helped me make the paper which is pure Gampi, one of the most important traditional papers which is both beautiful and functional. Images are taken from wood by the *ukiyo-e* process and then intaglio over-printed with etched copper plates. The imagery often found in my prints traces the erotic art of the historical old masters' work. Their works are combined with my own to make a personal contemporary visual statement.'

yin and *yang*, as both the masculinity of cutting and the feminity of printing is balanced within the empathetic touch of the printmaker's hands.

In the mid-19th century, the exotic world of *ukiyo-e* prints unfolded in Parisian hands on the wrapping paper for merchandise sent from Japan. Many artists, including Van Gogh, Lautrec and Gauguin, were inspired when they saw the colourful and planar qualities of these prints, so cheap and plentiful to the Japanese, yet strange beauties to the European eye. Gauguin recognised the pulse of nature within the flat grain of wood which through brilliant colours recalled a paradise lost beneath a fast-developing industrial world. The Western interest in the woodcut was recharged as the traditional printmaking practices of the two cultures became fused. This integration has been most apparent in America where there has been a constant network of exchange and study between American and Japanese printmakers.

Currently, there is a rapidly growing use of Japanese techniques in England. Walk into any of the leading printmaking suppliers' shops and you are greeted with a wide range of tools and handmade papers from Japan. A quiet revolution is stirring. As mechanised equipment stretches the graduate's pocket and environmental issues create ever-more concern, the impulse for creativity is drawn towards the subtleties and immediacy of the safer, toxic-free hand processes.

In keeping with the committed pursuit of any craft, Japanese wood-block printing takes many years of practice to perfect. The following information is an introductory guide to the basic printing procedures which I hope will stimulate more extensive exploration of the medium. I recommend that readers turn to *Japanese Woodblock Printing*, another book in this A & C Black series in which Rebecca Salter provides a fully comprehensive account of the medium based upon her many years of experience in this field.

The working space, tools and materials
Traditionally, a Japanese printmaker sits in a kneeling position on the floor and has all the equipment he/she needs economically situated at arm's length. When cutting, the block is placed on a board which is positioned on the floor in front of the knees and tilted towards the body. In kneeling, all the body weight is exerted on the arm which holds the *baren* for print-ing. Pigments, paste, brushes and tools are kept in a small cabinet on one side of the printmaker and the stacked, dampened printing paper is laid out on the other side. The kneeling position on the floor may be ideal if your working space is small, otherwise a table-top, good lighting and a supply of water are all that is necessary.

> *hanga*: the Japanese technique of printing blocks with
> water-based colour.
> *moku*: wood.

The traditional woodblocks are made from maple, cherry and sycamore. Cherry is hard to cut but withstands many printings. Today, Japanese printmakers use blockboard, wood from the katsura tree, shina-faced and lauan-faced plywood. Shina (Japanese lime) is soft and light, and has an almost invisible grain. Lauan (a Philippine mahogany) is a medium-weight hardwood with a straight and evident grain.

The blocks are cut with three types of tools: the *to* knives for cutting outlines and which are held in the hand like a dagger, U-shaped gouges and flat chisels for clearing negative areas and the *kento-nomi* chisel for cutting the *kento* registration channels. A small mallet is used in conjunction with the largest gouges and chisels.

The *baren* is the essential tool for hand burnishing. It is composed of a twisted coil of string fibres resting against a thin backing disc of laminated

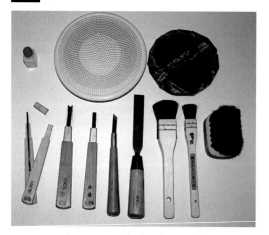

Japanese tools, brushes and *barens*.

paper. These are covered in a smooth bamboo sheath with the ends twisted together to form a handle. The bamboo sheath is kept moist with a few drops of Camellia oil to maintain the softness of surface that enables burnishing sympathetic to the paper and block. The making of *barens* is a traditional craft and the best are very expensive. Less costly *barens*, including plastic versions, are commercially available. Traditionally crafted *barens*, of which there are six kinds, have an average diameter of 12 cm (4¾ in.).

Although oil-based inks are used at times today, watercolour remains the medium that is synonymous with Japanese woodblock printing. Pigments, gouache, poster colour, acrylics, *Sumi* ink and powder colour are employed to achieve the distinctive qualities of the Japanese print. Water-based pigments present light, transparent graduated hues and tones, whilst gouache usually gives a more opaque and uniform colour. Poster colours mixed with water and gum Arabic provide a thick coating of ink and the dense black soot of *Sumi* (Chinese black ink) resonates a rich warmth from within the paper fibres.

Synthetic dyes can be used instead of pigments and water colours. Ten gm of powdered dye is boiled for five minutes in 100 cubic cm of water with a pinch of salt to make the colour fast.

If pigments are used for colour they must be finely ground and dissolved in water to make a thick cream. Add 10 ml (2 tsp) of gum Arabic to every 65 ml (5 fl.oz) of pigment. Gum Arabic is made by crushing and dissolving 50 g. (2 oz) of dry gum in 1 litre (1¾ pints) of hot water. The saturated pigment and gum Arabic mix can be preserved in airtight jars for up to a year by adding 1% by volume (10% solution) of phenol.

Colours are transparent, matt or opaque. A paste is used to create mattness and brilliance. The paste is applied to the block before the colour is brushed on.

The paste is made using finely ground rice obtained from a Chinese or Japanese grocer. Put about two teaspoonfuls of the ground rice in a cup – gradually adding water and stirring until the mixture has the consistency of smooth cream. Boil half a pint of water in a saucepan and add the mixture slowly, stirring all the time until the liquid thickens. Simmer gently for five minutes. On cooling, the paste should be smooth and almost fluid enough to pour. An alternative to rice paste is a mixture of

methyl cellulose and water. Unlike the rice paste, the mixture (1:7 parts of water) does not form a mould. Museum and conservation paste, supplied by specialist shops, is the simplest to use.

Rectangular (*burashi*) brushes made of dense horsehair (which look like shoe brushes), are used for spreading the watercolour across the block. Smaller brushes, (*tebake*) are used for detailed areas. Many suppliers sell three *burashi* brush sizes of lengths: 15, 24 and 60 mm (⅝, 1⅜ and ½ in.). The outer edges of the *burashi* brush are rounded off and the hair ends are split to hold reservoirs of ink.

A favoured Japanese paper (*washi*) for block printing is made from 100% kozo fibres from the mulberry tree. Unsized paper should be very lightly sized before printing.

Size (*dosa*): Over a gentle heat, melt 2 tbsp of rabbit-skin glue in one cup of water, stirring all the time. If the paper is thin then the glue should be thinned accordingly with additional water. Make a thick glue for heavy paper. Add 5 ml (1 tsp) alum to each litre (1¾ pts) of water. Using a soft, wide brush, apply a thin coating of size to each sheet of paper in turn and hang them up to dry. Immediately apply another thin coat of size to the backs of the paper and leave to dry completely.

The printing procedure

1. The bottom edge and left-hand corner (reverse side) of each sheet of paper must be cut to register within the *kentō* stops (see p.50 for *kentō* registration).

2. Lightly sand the wood before transferring the drawing.

In multiple colour printing, the colours are separated onto several blocks for individual cutting and printing. The original drawing, accompanied by clear indications of registration, is transferred to each additional block. In the traditional Japanese method, a key block of outlines is cut first. Printed copies are taken and glued down onto each colour block. The positions of the *kentō* stops are marked on the block and the colour areas are cut using each gummed print as a guide. The *kentō* stops are cut out with the *kentō-nomi* chisel before printing commences. The cut must be absolutely vertical and the groove shallow to permit accurate registration.

3. Dampen the paper before printing by interleaving between sheets of wet newsprint.

4. Moisten the underside of the block and place on two or three sheets of dampened newsprint to prevent the block from sliding.

5. Brush water over the whole block or the area selected to be printed using a clean, wide, flat brush (*mizu-bake*). Allow a few moments for the water to penetrate the wood but with some remaining on top.

Above: Noboru Sawai brushes colour onto the block with a *burashi*.

Top, right: Noboru Sawai hand burnishes the print with a *baren*.

Bottom, right: Noboru Sawai lifting back the completed relief print. He over-prints this with an intaglio plate through an etching press.

6. Apply the colour to the surface of the block with a smaller hog hair brush or *tebake*. Use a larger *tebake* for spreading the colour. The colour should merge with the block. If there is a residue on top too much colour has been applied.

7. For matt and opaque colour dab a few spots of freshly prepared paste onto the block with a small stick before adding the colour.

8. Brush the colour and paste together evenly over the block using a large *burashi* brush.

9. Lay a sheet of paper on the block locating the bottom corner and edge in the *kentō* stops. Place a sheet of greaseproof paper on top to protect the printing paper whilst burnishing.

10. Applying firm pressure from the shoulder, burnish the paper with the *baren* using a circular motion of the hand.

11. If the ink is very transparent printing may be repeated straightaway several times to gain the required intensity. Between each printing dampen the block and reapply the colour as before.

12. The paper must be kept moist until all the printing is finished. Stack the paper between dampened sheets of newsprint and cover with a sheet of plastic.

13. When all the printing is finished allow the paper to become partially dry before interleaving the prints between sheets of acid-free, white cardboard, compressing with heavy weights until flat and dry.

Metallic powders and mica dust are easily applied to a print taken from a block that has been brushed with glue or varnish. The powder is sprinkled onto the tacky surface and any excess is blown away leaving a thin deposit adhered to the surface of the print.

Bokashi

Bokashi is one of the best-known of the many techniques involved in Japanese block printing. The much-practised printmaker can, with a skill equal to the conjuror under whose hands the rabbit vanishes, produce that beautiful, background blush of colour which magically evaporates to the invisible across the print. The illusion of infinite depth and an enigmatic spacial dimension, are the transient qualities of *bokashi* and the floating world.

The *bokashi* colour is brushed across the block against the grain. Take the following procedure to produce a single, fading background colour with the greatest colour strength at the lower end diminishing towards the top of the block.

1. Brush water on the block with a large, flat (*mizu-bake*) brush, and wipe the block with a rag leaving a little more water on the block than previously, especially at the top end.

2. Spread the colour in a strip at the lower end with a small (*tebake*) brush.

The Western technique of 'fade out' is comparable with the *bokashi* process. Here, an acetate shape, rolled up in oil-based ink, is lifted to place on a block.

3. Put a few dabs of thinned paste on the colour strip and at the top of the block.

4. Starting at the bottom, take the rectangular (*burashi*) brush and sweep the colour from side to side in regular strokes. Gradually move the brush towards the top end continuing in consistent 'to and fro' sideways movements.

5. Take a print and remove the paper. For intense *bokashi*, or any solid colour printing, it may be necessary to strengthen the first colour so two or more printings are made one over the other. The block is dampened and re-inked between each printing.

'Passage from Japan' by Roslyn Kean, Aus. Woodblock with gold leaf, 100% kozo paper, 18.5 cm x 29 cm (7¼ in. x 11½ in.) 1998.
Roslyn uses traditional *barens* and her own manufactured stainless-steel ball-bearing *baren* which exerts much pressure on her heavy-weight paper. She applies a drop of oil to the surface of a thin sheet of acetate and places this between the paper and *baren* when burnishing. The final block to be printed contains the image for the gold leaf. The block is inked with a special solution that contains a strong binder to which the loose leaf will adhere after the block is printed. Roslyn has travelled and studied extensively in Tibet and China. She is inspired by the spiritualism of Buddhism, the blue and gold used in Tibet, and the sacred symbolism of stones.

Contemporary Techniques

Embossing on the press

Embossing on a press has many similarities with the hand process of Chinese dab printing. An intaglio or hydraulic press give the deepest embossed effects whilst a platen press produces a lighter impression. Plenty of soft packing is needed on top of the paper; a thick sheet of foam rubber works extremely well.

Relief blocks are ideal for embossing. Lino, wood, metal, layered card and many found objects all provide suitable surfaces. Blocks can be inked, partially inked or 'blind' embossed without ink so that the white paper surface alone portrays all the subtleties of light playing upon the relief surface. Thick, heavy paper should be used which has been sized to give it strength. The paper must be thoroughly dampened to allow the fibres to be moulded into deep cuts and recesses.

'Dos Origamis' by Omar Rayo, USA. Intaglio, 300 lbs Arches paper, 56 cm x 76 cm (22 in. x 30 in.) 1977.
Omar's zinc plates are 3–5 cm thick to enable very high relief in the embossed prints. At times he etches hollows right through, protecting the relief edges with careful varnishing, and bevelling the sharp edges afterwards to avoid cutting the paper. He uses a felt blanket on the press, or, for very deep embossing, presses the damp paper into the recesses with fingers or round-ended metal tools. The paper remains on the plate until it is dry. Omar has also used patterned layers of card built up with rabbit-skin glue and gesso for his embossed prints. In the alchemical sculpting of ore and fibre *Dos Origamis* bears a sculptural identity which defies the single definition of an intaglio print.

*'Considerations of Order and Chaos'
by Jerzy Grabowski, Poland. Relief-
embossed, 18-colour linocut,
70 cm x 100 cm (27½ in. x 39⅗ in.).
Two editions of 12 and 19, 1992–94.*
After meticulous cutting, Jerzy
embosses his dampened *Hosho* no.741.
paper onto the lino block under the
heavy pressure of an etching press. He
leaves the paper to dry before remov-
ing it from the block. Then he prints
the colours by hand burnishing with
an ivory tool, using offset litho ink.
 Jerzy's absolute decisiveness of cut
and colour composition represents the
structures of light and matter.

Some printmakers use laminated sheets of paper, printing and building up thin sheets one at a time. For this method, the first, fairly thin, sheet is placed on the block and run through the press. The paper is then given a thin coating of paste before another sheet is placed on top and the block put through the press once more. The embossing is deepened each time. In an alternative method a sheet of paper is placed on top of the block and paste applied only at the edges of the back. A second sheet of paper is placed over the first and both run through the press together. In a dry state, metallic coated card and thin aluminium sheet emboss well.

Sculptors may find experimentation with vacuum forming and embossed printing furthers the unity of both dimensions.

Plaster blocks

A plaster block is made by pouring Plaster of Paris into a stiff card-board or wooden frame which is placed upon a sheet of glass. The frame is sealed around the base with clay or plastic tape. When the plaster has set, the block is easily released from the frame and the smooth underside is turned face upwards. When the block has dried, the surface can be cut with knives, gouges and engraving tools. Ryszard Otreba makes two thin blocks from one frame turning the first block smooth side face up onto the second one whilst it is still setting. This way he has a block with two perfectly smooth, flat sides.

Ryszard describes the next stage of his working process:

'When the block is completely dry I apply between four to six brush coats of shellac (10% shellac/90% methylated spirits or denatured alcohol) to the plaster block at two-hour intervals. I paint the surface with black Chinese ink and trace a white crayon or chalk drawing over the top.' For precise cutting-control Ryszard has made his own tool with a cutting edge shaped like the letter 'W'. The double teeth are useful for drawing parallel lines. He uses an ordinary knife too, holding it at an angle to make a

single-stroke cut with one broken edge or a two-stroke cut with a sharp 'V'-shaped profile.

Both Plaster of Paris and dental plaster give extremely fine detailed casts. Low-relief plaster blocks can be cast from lino and wood blocks, metal plates, textured slabs of clay, collagraphs and found objects.

Plaster surfaces are printed with oil-based inks and should be hand burnished.

Paper pulp casting

Printmakers wishing to conserve natural resources by recycling materials make their own matrixes by casting paper pulp forms from plaster moulds. It is advisable to apply a thin coating of wax releasing agent to the interior of the plaster mould when paper pulp casting.

Ruth Faerber casts handmade paper reliefs from plaster or styrofoam negative and positive moulds. First she makes her own paper by the traditional mould and deckle method, using the pulp of recycled white archival matt board. For casting she takes a still moist and malleable sheet of paper and lays it over or into the plaster

'Apparent Order V' by Ryszard Otreba, Poland. Plaster print with colour elements printed from lino, oil-based ink, hand-burnished, Hosho paper. *76 cm x 51.5 cm (30 in. x 20¼ in.) 1996.* Ryszard Otreba is Professor of Visual Art and Design in the Faculty of Industrial Design at the Academy of Fine Arts in Krakow. He is a pioneer in plaster block printing.

mould. She gently presses the paper down by hand-pushing it into all recesses. The paper is allowed to dry naturally before removal from the mould. The relief cast is hand-painted with acrylic spray paint to achieve the illusion of textured and weathered stone.

Relief-printed collage blocks

A collage block is ideal for relief printing by itself or combined with other blocks. The process involves building up a relief surface with collaged materials onto a lino, hardboard or woodblock. Objects such as cut or torn shapes of card, string, crumpled tin foil, scrap metal and perforated mesh, fabrics and string can be fixed in place with PVA wood glue.

Another similar approach is to place the objects without gluing onto an inked lino block and run them through the press with proofing paper on top. The paper and the objects are then removed and a second sheet of paper is placed down to take a print of the impressions remaining in the inked surface. This process, a form of monoprinting, can produce fascinating results. Sometimes the objects leave interesting indentations in the block which can be utilised in further stages of printing.

'Guardian Spirits' by Ruth Faerber, Aus. Handmade, hand-coloured cast pulp, 74 cm x 101 cm (29 in. x 39 in.) ed. 6, 1996.

Gesso or household cellulose filler mixed with PVA glue provide texture for creating a landscape of low-relief surfaces. Gesso can be purchased ready prepared or you can make it by melting animal glue in a glue pot or double saucepan, slowly adding just enough Plaster of Paris to make a spreadable mixture. The mixture is spread onto the block with a knife or applied with a brush. When gesso has hardened the surface can be sanded, carved and engraved. Left alone, the brush marks have a free and gestural appearance.

Collagraphy and printing from card

A collagraph is a low-relief block made from thin material such as card, lino, sheet metal or plastic. The thin block and detailed surface is generally regarded as most suitable for intaglio printing. However, the blocks can be relief-printed with equal success to reveal a wide range of mark making unique to this process.

Card is one of the simplest and most versatile of materials to use for collagraphy.

Rigid, gloss-coated display board, available in thicknesses of 750, 1,000 and 1,250 microns, is ideal for relief printing and needs no sealant unless any cutting exposes the inner porous layer. The smooth surface produces clean knife cuts and the finest of electric engraving tool marks show clearly in the print. Display board is sufficiently robust to take texturing with coarse sandpaper, rotary sanding disc, wire brush, and multiple tool engraving.

If your choice of card has a porous surface it can be sealed with two thin coats of shellac before printing to prevent ink absorption.

'Baths of Caracalla' by Clare Romano, USA. Intaglio and relief printed collagraph, 10⅜ x 31⅞ (4 in. x 12 in.) ed. 100, 1972, Italia paper. Collection of the Museum of Modern Art, New York City.

Gesso was used to stick raised areas, textured papers and cloth to one base plate of archival museum cardboard and for creating other textured areas. The plate was sealed with acrylic spray.

Card block for 'Pattern' by Kee Moi Soh, UK/Malaysia. 17.5 cm x 24.3 cm (7 in. x 9½ in.) 1989.

Kee Moi Soh transferred her 'Pattern' image from the computer to one thin sheet of A4 card using a Textronix 4662 pen plotter. Then she cut out the lines and recesses with a 'V'-shaped gouge and applied two thin coats of shellac to both sides of the block before inking and printing the block in relief.

Occasionally areas of shellac may peel off when the ink is rolled on but this can add a pleasing texture to the print. Alternatively, a sealant of acrylic emulsion or slightly thinned PVA wood glue can be brushed on which bonds items such as paper shapes and fabric fragments to the surface. Texture is created in wet PVA glue by dabbing with a small sponge or crumpled tissue, fashioning with a palette knife, or drawing with a broken saw blade, the end of a brush or an old comb.

A card block is a good substitute for lino when only simple, flat shapes are required. Cut or torn card with frayed edges is excellent for quickly making adjustable colour blocks whilst perforated or corrugated surfaces give beautiful and delicate textures.

Etching lino with caustic soda

Granular tones, sweeping brush strokes and fine lines are the main characteristics of the caustic etching process. When a simple etch solution of sodium hydroxide and water is applied to a lino block, the surface is broken down creating textures ranging from the softest delicacy to the roughest grain. Sections of the block can be masked using resists of etcher's stop-out varnish or candle wax so that selected areas of the surface are etched alone. After etching, the block is washed in water and the resist designs are cleaned off with the appropriate solvent. Once dry, the block is ready for inking and printing. In a relief print the unetched, design areas will translate as solidly defined form whilst the lowered parts will appear as tone and texture with qualities varying according to depth, type of grain, ink application and printing pressure.

A simple caustic etched lino block print by Ann Westley.
First I de-greased the block and brushed on the face drawing with etcher's stop-out varnish. Then I coated the surface with caustic etch solution for about two hours, rinsing and drying it thoroughly, before inking-up with a hard roller and printing on my platen press.

Preparation of the lino block

1. Rub the lino with methylated spirits (denatured alcohol) to clean the block and remove grease.

2. Protect the back and edges of the lino with a brush coating of PVA glue or etcher's stop-out varnish.

'*Liquito*' *by Michael Rothenstein, UK. Etched colour linocut, 84 cm x 59.3 cm (33 in. x 23³/₁₀ in.) 1962. Courtesy of Birmingham Museums and Art Gallery.*
Michael's excitement of his discovery of this new technique is joyfully expressed in Liquito's spontaneous brush marks and vibrant colour splashes. *Liquito* owes its very composition to liquid; the print clearly demonstrates the immediacy of the process.

Mixing a saturated etch solution

1. Put three to four tablespoons of cold water in a glass jar or polythene container.

2. Add caustic soda (sodium hydroxide) crystals to the water, one spoonful at a time, waiting for the crystals to dissolve before adding more. When no more crystals will dissolve, the solution is saturated. Stir with a glass rod or wooden stick.

3. Slowly add wallpaper paste powder, a teaspoonful at a time, stirring all the time until the solution has thickened to a brushable consistency. Janet Brooke uses flour instead. The solution will heat up to a high temperature. Leave the jar in a safe place to cool down after which it is ready to use.

Application of the resist design

1. For work in wax you will need a double boiler and a nylon brush. Heat the wax in the boiler until it has thoroughly melted. Brush the wax straight from the boiler onto the lino. If the wax has a chance to cool down it will not adhere firmly to the lino. Try other effects by dripping and dribbling the wax from a spoon.

2. Stop-out varnish can be brushed, splattered or offset from textured materials. There should be a good coating of varnish which must be thoroughly dry before applying the etch.

n.b. Needle points and other implements can be scratched into either resist when they are dry. Decorator's masking tape, well-burnished onto the lino, provides a good resist too. Childrens' modelling clay or mouldable adhesive walls can be used to isolate specific areas for etching.

Etching

1. Wear rubber gloves and goggles and keep a container of water nearby to wash any areas of skin which may get splashed. Also avoid breathing in the fumes given off during etching.

2. Protect the working surface by placing the lino on a glass slab or in a plastic tray.

3. Apply the etch solution to the exposed lino with a nylon brush, cotton bud or a cotton dabber tied to a plastic or wooden stick.
 The speed and intensity of etching depends upon several factors: soft, new lino etches faster than old, hard lino; etching is faster in a warm environment than a cold one; the longer the etching time the deeper the bite will be.
 A shallow bite which gives a halftone or aquatint effect takes two to three hours. A deep etch takes five to six hours.

Leave the etching solution on the lino overnight for a very deep etch. The solution loses strength after a few hours, ceasing to etch, so the lino should be washed in water at these stages and fresh solution brushed on.

4. When etching is completed, the block is thoroughly cleansed and rinsed in water. Use a stiff brush to remove all traces of etching solution and wipe off any excess moisture with a rag. Remove any modelling clay and resists. Clean off varnishes with White spirit or methylated spirits (denatured alcohol). Much of the wax can be scraped off with a palette knife, the remainder removed by heating the lino with a hair dryer or placing on a hot plate. Lay absorbent paper over the lino to soak up the softened wax or run a heated iron over the top of the paper. De-grease the lino with methylated spirits (denatured alcohol) and leave to dry.

5. The block is now ready for inking and printing. In proofing, a hard roller, a light application of ink and dry paper are recommended to reveal the full potential of this process.

'Pilot' by Ann Westley, UK. Lino and wood cut, 89½ cm x 62 cm (35 in. x 24 in.) ed. 8, 1994. A combination of reduction and multiple block printing using the caustic etch process throughout.

'No Ball Games' by Janet Brooke, UK. Caustic etched linocut and card block, 76 cm x 56 cm (30 in. x 22 in.) ed. 8, 1990.

The erosion of surface in the print applies equally to its subject of urban decay and the technique of etching. Two background lino blocks were freehand-etched without any resists. The main block was etched using a commercial resist (employed in the printed circuit-board industry) which Janet screenprinted through a photo stencil onto the lino. When the screenprinted resist image was dry she brushed etching solution over the block leaving it overnight for a deep etch. There were six stages of printing using hard rollers and dry Somerset paper. The main block was printed last in black.

Chapter 6

SMASHING
THE GLASS

■ ## Extending the dimensions of the relief print

Several Tibetan Buddhist stone carvings, woodblocks and accompanying prints are stored in The Ipswich Museum, in Suffolk. Mantras and gods are relief-printed from single, finely delineated lines. No additional tone or colour blocks are required to illuminate the inner and outer space.

Printed Tibetan prayer mantras are like playing cards; they are placed in a cloth-bound box which shares the same dimensions as the blocks. When the box is closed, the lid is secured by a tied ribbon. The physical act of opening, holding and closing all together, demonstrates – like breathing – an integration and unfolding of all the dimensions.

The glass is smashed and a perception of the relief print as a multi dimensional form emerges from the picture frame.

A technique for printing in three dimensions

Descriptions of letterpress typesetting, book binding and construction require space far beyond the perimeters of this book. The few books shown here represent the great diversity of imaginative work currently being produced which I hope will encourage readers towards further experimentation of their own. Your choice of book construction may necessitate collaboration with a professional printer and book binder or can be carried out easily in your own studio with materials and tools already to hand. It is

Two hands holding the 'Brick Book'.
From the collection of St Stephen Museum, Szekesfehervar, Csilla Kelecsenyi, Hungary, 1998.
Using her own paper pulp, Csilla casts the surfaces of objects found in the urban environment. She says, 'The pavement is the land's skin. A saint land.'

'AMOROMA' ('I love Rome, or the scent of love') by Ken Campbell, UK. Sculpture, letterpress printing, paper, varnish, bronze, wood, steel and nylon fishing line, ed. 3, 1985.
Seven sheets of (varnished) translucent paper each bearing two columns of the palindrome AMOROMA set in vertical attitude carrying seven repeats equally of red and black printed letters. As a mantra of six syllables, six spaces are created between letters and sheets. Beneath this 'heaven' stride three 'earthly' hooves in triangular formation. The work was inspired by a Tibetan banner book in the British Museum.

'Thomas Traherne. A Glimpse' by Ann Brunskill, The World's End Press, UK. 47 cm x 33 cm (18½ in. x 13 in.) ed. 50, 1978.
Full-page multicoloured woodblock prints, produced by painting the blocks in watercolour, stand opposite the text of the 'Centuries' and the poems in 24-point Baskerville Roman. Printed on BFK Rives Velin Cuves. Bound in quarter leather with an individual monoprint to cover each book. Hand-painted end-papers. Linen slipcase. The style of Ann's books is determined by their content. All the work is done in her studio except for the stitching and binding. Ann prints on a 19th-century Lion hand-press or a smaller Vandercook.

'373 717' by Les Bicknell, UK. Handmade book with letterpress type,
25 cm x 18 cm (10 in. x 7 in.) ed. 6, 1993.
Les Bicknell is one of Britain's leading innovative book artists. He uses many media
and writes, 'You get the best of both worlds when you combine the possibilities
of computer manipulation with the textures and qualities of relief printing'.
 373 717 is an experimental sculptural book form which explores the idea of
form relating directly to content. Through folding and binding the landscape is
documented. Letterpress text and collagraphs along with stamped cardboard
inserts are used as notations within the three sections. *373 717* is placed
within a stamped cardboard box. This bookwork explores the concept of book
as sculpture and can be 'read' equally well in the hand as on the plinth.

'The Thin Blue Line' by Deb Rindl, UK. A handmade concertina book with blue cord
threaded through punched holes in the pages. Letterpress type printed on
a Vandercook cylinder press at The London Institute, Camberwell,
30 cm x 13 cm x 2.5 cm (12 in. x 5 in. x 1 in.) boxed, 1996.
The blue cord is like the meniscus line of surface tension where water meets air.
It weaves through the book describing the elemental forces which sculpt the form
of each paper surface.

good to know too, that wood and metal type is still found (like buried treasure!) in many studios and in some art colleges. If it is not wanted, grab it – and a technician who is willing to help!

Deb Rindl learned her craft on the MA Book Arts course at Camberwell College in London. Les Bicknell is a lecturer there too. They share a progressive approach to making books. Les breaks with all tradition, using any paper that suits his ideas. He told me, 'I begin by asking my students to fold paper into the shape of an idea,' while Deb writes, 'Sometimes I have a very definite idea, at other times I start with nothing and see what happens. The important thing is that the text, the form of the book and the 'illustration' all work together to form a whole – that the whole piece is expressing what the idea is about.'

'Once I have made a final dummy and have worked out exactly where I want the type to go, I then proceed to do the letter-press typesetting. There is always adjustment required and invariably, it takes longer than expected. I always print more copies than is necessary, as there are inevitably duds along the way. It is very satisfying to see the beautiful effect of the letter-press on nice paper. Once all the printing is done on the flat paper, I do the folding, joining, etc., to make up the books. I use a bone burnisher for paper folding.'

See the Bibliography for two practical books which Deb recommends to help the reader.

'Home for Hominstructs' by John Ross, USA. A 3D Artist book, ed.15, 1996. Collagraph and Linotype Helvetica text, 61 cm x 56 cm (24 in. x 22 in.), collections: V & A, London; New York Public Library, USA.

'65 degrees 57 degrees 58 degrees' by Megan McPherson, Aus. Relief print, Intron. Copy press transfer, copper, cord. Paper panels: 30 cm x 30 cm (12 in. x 12 in.), 15.5 cm x 15 cm (6⅛ in. x 6 in.). Solander box: 16 cm x 16 cm x 2 cm (6¼ in. x 6¼ in. x ¾ in.) 1996.
Megan writes, 'The Japanese restoration tissue prints are a sort of map based on the triangle shape formed between the blue ovals; the copper mimics this form and the cord is the length of the sides of the triangle.' Megan's work is inspired by the astronomical investigations of Ptolemy.

'Genesis – A Book of Life' by Angie West, UK. A sealed jar containing water and printed paper. 24 cm x 13 cm (9½ in. x 5 in.) 1997.
Angie writes, 'The sentence "In the beginning was the Word..." was repeatedly printed in two colours on strips of tear-proof paper using a hand-operated Adana letterpress printing machine and folded to represent intertwined DNA strands. A printed panel of text from the Book of Revelations 5, verses 2–3, forms part of the lid, which is sealed seven times with wax imprinted with the letters G.E.N.E.S.I.S.'

SMASHING THE GLASS

A technique for revolution

Printmaking involves modes of practice central to a sculptor's vision and vocabulary. The physical engagement of relief printmaking is one of the immediate attractions for many sculptors. The same tactile sensitivity of the sculptor governs every action of the printmaker in cutting and shaping space, modelling degrees and variations of light, colour and texture on a section of wood, or constructing etched and welded metal forms for surface printing.

A piece of sculpture is most often the final realisation of a concept while the constructed, cut or carved relief block evolves a second phase into a further transformation upon the printing paper. While the cast sculpture does a complete 360° revolution as it is removed from the mould, the print has to be content with half that measure – a 180° turn. Either process requires a series of mental flips which regenerate and energise creativity. Holding onto the aim of the work while performing all the intricate mental equivalents of a revolving gymnast becomes customary practice for both the sculptor and the printmaker.

'Sudden Shower' by Lesley Duxbury, Aus. A relief-print installation, 3.5 m x 8 m (137 in. x 315 in.) 1999.
Almost a thousand strips of paper, 3 cm x 20–30 cm (1⅛ in. x 8–11⅘ in.) long, were printed ten at a time from a sheet of uncut lino. The sheet was inked-up in grey gradations for most of the strips, then in colours of the spectrum for printing strips to form a rainbow arc within the shower. Lit by a spotlight representing the sun, each print, attached to a same-size strip of Fomecor, casts a shadow on the wall. Lesley creates a multi-dimensional print where the viewer is immersed in the experience.

Once a sculpture is cast it may be a simple procedure to cast many more copies but it can be difficult to make radical changes to the finished form. Conversely in relief printmaking, the possibility for changing the appearance or developing a sequence of variations is infinite. Metamorphosis is possible at every stage of the process with each action, from the first cut to the final pressure, determining the outcome. Proofing is analogous to shaping a clay form where the sculpture can be worked through many additive and subtractive states until the modelling is resolved. If an editioned print is not the aim, the freedom of experimentation liberates a multitude of characters from the block with each unique personality voicing an individual expression of the whole.

There are sculptors and printmakers who continually slip between the media, freely combining properties of both dimensions in their work. Peter Latham is one such artist whose primary interest lies in the relationship between the human figure and the landscape. He is interested in the marks created by the chainsaw, an instrument which has changed the face of many landscapes, replacing forests with open fields now textured by plough and crop.

Peter writes, 'The sculpture stems from seeing the figurative potential and print possibilities in a piece of elm which bears the marks of the chainsaw. The two prints are part of a series of sculpture-related prints in which I have avoided the traditional approach of over-printing colour with the graphic structure in black which can destroy the fine texture.

'Karyotypical ♀' by Richard Falle, UK. 64 cm x 24 cm x 5 cm (25⅛ in. x 9½ in. x 2 in.) 1998. Wall relief with mounted letterpress zinc type. Handmade chromosome forms replace the typical faces of each body of type.

SMASHING THE GLASS

'Carved Head I' by Peter Latham, UK. Oil-based inks, Somerset 300gsm, 105 cm x 77 cm (41³/₁₀ in. x 30³/₁₀ in.) 1996.
There are three background colours press-printed from three blocks: gesso on card, torn paper on card and shuttering ply. Peter used plastic shapes for the saw-blade motifs. The central profile which was hand-burnished, has two printings: red from gesso on card and brown from an elm woodblock which he carved later, making the sculpture, 'God Head'.

'Carved Head II' by Peter Latham. Five-colour woodcut printed from 'God Head' and shuttering plywood, 105 cm x 77 cm (41³/₁₀ in. x 30³/₁₀ in.) 1996. Printed in the same manner as 'Carved Head I'.

Below: 'God Head' by Peter Latham. Carving in elm, 48 cm x 60 cm (19 in. x 23½ in.) 1996.

Instead, these are printed from light to dark in layers of colour with up to eight separate printings. Further timber references are added by over-printing wood-grain textures in the area around the head. The image is printed by burnishing heavily, working the paper into deep marks to create a strong surface texture. The prints also work as a record of the development of the sculpture, as a means of developing ideas about it and colours to use on it.'

The work of Richard Falle suggests an access to the medium for the conceptual artist. Richard observes the evolving growth, structuring and pattern of the genetic landscape and sees a direct correlation in the practice as well as the language used to describe the printmaking processes. In 'Karyotypical ♀' he employs the anatomy of the traditional letterpress body to translate the contemporary language of genetics. The potential prints of two rows of chromosomes are confirmed in the minute figures raised up as two 'sentences' of metal type. The matrix of his wall sculpture contains the information for life and the text by which it is recorded. Printmaking is symbiotic with life, an identikit for duplication, reproduction, and transcription.

In her installation, 'Passage', Ruth Johnstone has liberated the print from the familiar confines of frame and glass to the floating surface of ceiling-hung paper. She creates a 'living room' without walls where the paper 'breathes' as the spectator walks through. Ruth used *Hosho* paper for its durability, semi-translucence and wallpaper format. 'Passage' incorporates printing from 19th-century wallpaper blocks. The wood-cut prints of rosemary and lavender were hand-cut from mostly plywood blocks and printed with oil-based inks. Additional lustre was created by bronzing with pearl and gold dust while a layer of the ink was still wet.

'Passage' by Ruth Johnstone, Aus. Woodcut installation, 240 cm x 450 cm x 520 cm (94½ in. x 177 in. x 204¾ in.) ed. 1, 1994.

*'Humpback Whale' by Julian Meredith, UK. A zig-zag woodcut using 12 blocks,
1.83 m x 7.32 m (72 in. x 288 in.) 1993.*
The print is taken from shuttering plywood which was partly smoothed with a
cabinet scraper and roughened elsewhere with a rotary wire brush. Oil-based inks
were rolled on with three large rollers and several colours were merged together.
The print, on Korean handmade paper, is shown hanging from wires in the disused
Cummins engine factory in Darlington.

Detached from the constraints of editioning, and bearing no signature,
date or number, the identity of the print subscribes to the subjective,
tactile and sensual experience of the spectator.

Finally, there is the mighty *Humpback Whale,* by Julian Meredith whose
love of the earth tells us that if we protect the wood and the whale, the
relief print will continue to swim through the future in all dimensions.

Chapter 7
BON À TIRER
(THE FINAL PROOF)

When I visited Akiko Fujikawa's exhibition at the Anglo–Japanese Daiwa Foundation in London, I noticed that at No. 10–11 was The Society for Mental Illness. Ever curious, I picked up a leaflet on schizophrenia before walking past No. 12 to see Akiko's work.

As artists we make connections. When at first I saw Akiko's prints of mask-like, split heads comprised of the floating profiles of several blocks, I interpreted them as divisions of the human psyche. Yet her prints are joyful, playful illusions created from entirely natural materials – *kozo* and wood – upon which she lightly balances the Noh drama of life where all is illusion. Beyond the point of her knife, which in true Japanese style she holds like a dagger, is the guarded tradition of the woodcut which stretches back through many centuries to the beginning of time. Akiko's creative process is entirely holistic except there is one alarming aspect. Recently, red spots appeared on her *kozo* paper when she dampened it in tap water. Nature is the litmus test of our technologies.

'You're kidding' by Akiko Fujikawa, UK/Japan. Five-colour woodcut, 32 cm x 24 cm (12½ in. x 9½ in.) 100% kozo fibre paper, ed. 75, 1998.

Akiko's studio is in a village not far from my own. She works entirely in the Japanese manner as if she is still in her home country. I am fascinated by all her hand crafts. She came to my studio and was equally intrigued by my European presses but unimpressed by my wooden spoon. Akiko learned her craft at The Asahi School of Art in Kyoto with Master Print Artist, Takeji Asano (who died in 1999). 'He was like Picasso is to the Western artist,' she said.

As she left I asked her, 'And is it true that the ancient woodblock processes are dying in Japan?' 'Yes', she replied, 'but there are still a few printmakers who keep them alive.'

So I tell you this story from my doorstep; the shared story of relief printmaking, which brings together many artists, who, like Shiko and Michael, seek the spirit in the wood.

We have much to teach one another. Should the crafts be lost then so are we. We must learn to balance the technology of the computer with the natural forces of the earth. In this way we create the perfect equation which is Unity as the Imprint of Life.

As a Western artist I began printing with the iron press on machine-made paper. Now, as I learn to hold the *baren*, and print with the natural materials of the earth, I hope that I am joining two hemispheres and nurturing a craft for all those who treasure that great beauty which is hidden deep within the tree.

Opposite: *'Twain' by Karen Kunc, USA.*
104 cm x 51 cm (41 in. x 20 in.) woodcut, 1996.
Karen writes, 'Twain is from a series of shaped prints that have a single numerical permutation (once twain, thrice fold) that suggest the spark of life, evolution, splitting in two, and multiplication of forms.' Karen breaks through the constraints of the reduction process with stencilled colour forms, masking off areas of paper to create the main, white geometric forms. She softened the strong *Nishinouchi kozo* fibre with a brush line of water so that she could tear the edges around the print. Recently she has made a number of books using torn edged prints, wooden pages, found objects and letterpress words. Karen's art is the visible expression of her creative process through which her inner energies are balanced with the rhythms of the outer landscape. There is no division separating thought and practice as all distinctions between her Eastern and Western processes dissolve.

GLOSSARY

Acetal homopolymer
Thick plastic sheet used for engraving.

Acetate film or sheet
Used for making stencils and masks, to set up accurate positioning for registration and for off-setting key block prints to other blocks.

Anti-drying agents
Additives to the ink which retard drying. Useful in spray form to save surplus ink.

BAT/bon à tirer
French for 'good to hold' The final working proof used as a guide to editioning.

Bled image
An image which extends to the edge of the paper.

Bleeding colour
Pigment which extends beyond the printed area causing a halo effect.

Blended colour
When two or more colours are blended by rolling or brushing on the inking slab or the block.

Block
The printing surface. Also called a plate by some printmakers.

Bokashi
A Japanese method of blending colours in woodblock prints.

Boxwood
A hardwood made into end grain blocks for wood engraving.

Burnishing
Printing without a press, applying hand pressure using a Japanese *baren* or a spoon.

Caustic etching
Etching a lino block using a solution of caustic soda (sodium hydroxide).

Chinese dab printing
An ancient method of taking a print from the raised surface of damp paper while it is pressed into the recesses of a cut block.

Collage block
A printing block made of collaged materials on a lino, wood, metal or card base.

Collagraph
A relief and/or intaglio print made from a collaged block.

Dabber
An inking pad made of soft leather.

Dolly
Poupee or tampon; cloth wrapped round a pad or a roll of felt used to hand-colour parts of a block in multi-coloured inking.

Driers
Additives, used in minute quantities, to quicken ink drying time.

Embossing
A raised design created when damp paper is moulded by pressure to a block or plate.

End-grain
A hardwood block cut from a cross section of trunk showing the growth rings of the tree.

Engraving
A general term for an incised mark, an incised block or a print taken from an incised block. Tools most commonly used are: the burin, spitsticker, tint tool, multiple tool, graver, bullsticker, scorper, and chisel.

Extender /reducing/tinting mediums
Transparent additives to water-based and oil-based inks that dilute the pigment colour while maintaining the correct viscosity for rolling.

Fade out/colour gradation
Ink applied to the block from a roller carrying strong colour at one end that gradually increases in transparency towards the other end by an increasing addition of extender medium.

Gesso
A mix of plaster of paris and glue used to create texture on linoleum.

Gouge
V or U-shaped tool to engrave lino and wood.

Heliorelief printing
Using a photo-mechanical process and a powerful resist film, photographic artwork is transferred to a wood, stone or glass block. Unprotected areas of the block are reduced by sandblasting leaving a relief surface for printing.

Jig-saw block
A block cut into pieces so a different colour can be applied to each part. All the pieces are reassembled to print together.

Kentō registration
A Japanese method of cutting registration grooves on a woodblock.

Key block
The block carrying a colour that provides the essential, unifying part of a design and to which all other colours are 'keyed in'.

Letterpress
A process of relief printing from type and blocks, usually commercial, that has been almost completely replaced by offset lithography and photocopying.

Light-sensitive coating
A coating on blocks, paper, film and plates which reacts to light by hardening in exposed areas. Also acts as a resist in etching photo relief blocks.

Line block, cut, engraving, plate
Commercial printing term for a photo-etched relief block in letterpress printing where only line and solid areas are used, i.e. there are no tonal areas.

Linocut, linoleum engraving
A print taken from linoleum.

Make ready
Layers of thin paper positioned beneath a block or within a tympan to even out irregular pressure points.

Monochrome
A single colour print.

Monotype
A unique, 'one off' print made by painting on a smooth surface and printing by press or hand burnishing.

Monoprint
Colour variant taken from a printing block; a unique version from a repeatable matrix.

Mounted block/plate
A thin block adhered to a thicker, rigid base of wood, card or paper to raise to type-height.

Multiple block printing
Printing from several blocks, each block carrying a separate colour.

Multiple coloured inking
Several colours are printed from the same block using small rollers, brushes, or a poupee and/or stencils to apply individual colours.

Offset print
A proof taken on acetate from a 'key block' and 'offset' printed onto another block.

Packing
Several sheets of paper, rubber or foam sheeting placed on top of the printing paper in a press to soften and distribute pressure.

Paper pulp cast
Relief or 3D casting from a found object, rubber or plaster mould.

Photopolymer film
A light sensitive, acid resistant film used for photo etching laminated onto metal, hardboard, wood and plastic plates for relief or intaglio printing.

Photopolymer plate
A thin, flexible metal or plastic plate pre-coated with a light sensitive emulsion, exposed with negative artwork for relief printing.

Plaster block
A block made from Plaster of Paris. Printing is done by hand burnishing.

Proofing
Taking trial or working impressions from finished blocks before editioning.

Rainbow rolling
see 'Blended colour'

Reduction block
A block from which all the colours of a print are printed as follows: usually the lightest colour is printed first, then the corresponding area of the block is cut away. The second lightest colour is overprinted on the first and again, the related block areas are eliminated. This reduction process continues until all the colours have been printed.

Registration system
The means by which paper and block are accurately aligned for precise location of each colour printing.

Relief etching
Surface printing from an etched plate.

'On the Farm' by Agatha Sorel, UK. Plastic intaglio and surface print, 80 cm x 58 cm (31 in. x 23 in.) 1971. This print bears all the three dimensional qualities of Agatha's prints and sculptures. The structural shape was cut out from Cobex plastic and burnt with a hot wire. Use a face mask if you try this out. The internal forms were drawn with a rotary tool and scraper. Surface printed bubble wrap provided the lower patterned grid of texture.

Relief printing
Also called surface printing. Printing from the raised, upper surface of any block.

Shellac
Methylated spirits (denatured alcohol) based varnish for sealing wood/card surfaces.

Size
A gelatine or glue used to coat paper and other materials to seal and strengthen them.

Solarplate
see 'Photopolymer plate'.

Stencil
Stencils can be made from paper, thin card or acetate. Ink is applied through a stencil opening onto a block. Stencils are used also to mask off sections of the inked block or part of a print.

Stenocut
A block made from rubber sandblasting stencil material used by stone masons.

Thinners
Water-based inks are thinned with water, some water soluble inks with vegetable oil, oil-based inks with boiled linseed oil, copperplate oil, poppy oil, Vaseline or turpentine substitute.

White line engraving
A characteristic of wood engraving where the design appears as white lines on a darker background.

Woodblock print
The Western term for a traditional Japanese woodcut.

Woodcut
A print taken from a side-grain or plankwood or any manufactured board such as plywood.

Wood engraving
A print taken from end-grain or cross-grain woodblocks. Occasionally used for woodcuts that are very finely worked with engraving tools, particularly very early woodcuts.

'More Don'ts (Kitekids)', by John Schulz, USA. Colour woodcut, hand burnished, 38 cm x 46 cm (15 in x 18 in.) 1998.

The original image, from a 1953 Michigan State Police children's safety pamphlet, was reworked using Adobe photoshop and a laser print-out then transferred to the block using acetone and hand burnishing. John enjoys creating images which 'are familiar things jerked out of context... at once humorous, strangely beautiful and vaguely threatening.'

BIBLIOGRAPHY

Artist/Author, contemporary artists' books, by Cornelia Lauf and Clive Philpott. Published for an exhibition of the same title by D.A.P. Art Publishers Inc. and The American Federation of Arts, 1998. ISBN: 1-885444-07-9 (paperback), 1-881616-94-0 (hardback).

Book Binding for Book Artists, by Keith Smith, Keith Smith Books, ISBN: 0-96376-825-5

Chinese Printmaking, printing and dabbing techniques, by Yu Qi Hui. Published by The China National Academy of Fine Arts, Hang Zhou. ISBN: 7-81019-177-2. Chinese ref. classif.: J.156.

Contemporary Graphic Art in Poland, by Richard Noyce, Craftsman House, 1997. ISBN: 90-5703-48-16

Evolving techniques in Japanese Woodblock prints, by Gaston Petit/Amadio Arboleda, Kodansha International Ltd, 1977.

Imprint, Australian quarterly journal of the Print Council of Australia Inc. ISSB 0313 3907.

Intaglio Printmaking by Ken Duffy, A & C Black, (forthcoming).

Japanese Prints Today, tradition with innovation, by Margaret K. Johnson and Dale K. Hilton, Shufunotomo Co., Ltd, 1980, ISBN: 4-392-90115-4

Modern Japanese Prints, 1912–1989, by Lawrence Smith. Published by The British Museum Press, 1994. ISBN: 0-7141-1461-8

The Nature and Use of Wood for Printing, a lecture by Joel Feldman at Southern Illinois University, USA.

Non-adhesive binding: Exposed spine sewings, by Keith Smith and Fred Jordan, Keith Smith Books, ISBN: 0-9637-6824-7

Non-Toxic Intaglio Printmaking, by Keith Howard, Printmaking Resources, ISBN: 0-9683541-0-6.

Printmaking Today, a quarterly journal of contemporary international graphic art, Farrand Press, 50 Ferry Street, Isle of Dogs, London, E14 3DT, UK. tel: +44 (0)171 515 7322. Fax: +44 (0)171 537 3559. e-mail: farrandprs@aol.com.

Printmaking with Photopolymer Plates, by Dianne Longley, Illumination Press, Australia. 1998, ISBN: 0-646-27392-2

Research in Oaxaca, Mexico and the New Graphicstudio/USF Direct Heliorelief Process by Eric B. Vontillius, Graphicstudio/University of South Florida (U.S.), 1998.

Relief printmaking, by Michael Rothenstein, Studio Vista, 1970. ISBN: 289-79846-9

Techniques of the Chinese print, by David Barker, forthcoming.

The Art of The Print, by Fritz Eichenberg, Thames and Hudson, London, 1976. ISBN: 0-500-23253-9

The (Baren) Encyclopaedia of Woodblock Printmaking:
http://woodblock.com/encyclopaedia

The Complete Manual of Relief Printmaking, by Rosemary Simmons and Kate Clemson (out of print).

The Complete Printmaker, by John Ross, Clare Romano and Tim Ross, The Free Press, USA, 1990, ISBN: 0-02-927372-2

Australian Printmaking in the 1990s, Artist Printmakers:1990–1995, by Sasha Grishin, Craftsman House, 1997, ISBN: 90-5703-39-17

Ukiyo-e, by Wendy Shore, Castle Books, Book Sales, Inc. 110 Enterprise Avenue, Secaucus, New Jersey 07094, USA. 1980. ISBN: 0-89009-485-3

Which Paper? a review of fine papers for artists, craftspeople and designers, by Silvie Turner, Estamp, 1991, ISBN: 1-871831-04-0

The Woodblock and the artist, the life and work of Shiko Munakata, catalogue of the artist's Hayward Gallery exhibition, 1991, Kodansha International Ltd, 1991, ISBN: 1-85332-071-4

Wood Engraving, by Walter Chamberlain, Thames and Hudson, 1978. ISBN: 0-500-68018-3

Wood Engraving, Here and Now catalogue of the 75th anniversary exhibition of The Society of Wood Engravers, The Ashmolean Museum, Oxford, 1995.

LIST OF SUPPLIERS

UK

Adana Graphic Supplies
162 Gray's Inn Rd
London WC1X 8ED
Tel: 020 7837 6353/fax: 020 7833 3527
(Adana presses)

Bewick and Wilson
29 Spennithorne Rd
Stockton on Tees
Cleveland TS18 4JN
Tel: 01642 672768
(presses)

The Blast Shop
S. Critchley and Son
Agecroft Memorial Works
Langley Rd, Pendlebury
Manchester M27 8SS
Tel: 0161 736 1794/fax: 0161 745 8071
(Anchor 125 sandblasting stencil)

Buck and Ryan
101 Tottenham Court Rd
London W1
Tel: 020 7636 7475
(hand and machine tools including
the Bosch PSE 180E cutter)

R.K. Burt
57 Union St
London SE1
Tel: 020 7407 6474
(paper stockists)

Centurion Die-Cutting Co.
E3 The Seedbed Centre
Wyncolls Rd, Severalls Park
Colchester
Essex CO4 4HT
Tel/fax: 01206 751780
(gold blocking and die cutting)

L. Cornelissen
105 Great Russell St
London WC1
Tel: 020 7636 1045
(tools, inks, paper)

Daler-Rowney Ltd
12 Percy Street
London W1A 2BP
Tel: 020 7636 8241
(general supplies)

Ensinger Ltd
Unit D
Llantrisant Business Park
Llantrisant
Mid Glamorgan
CF7 8LF Wales
Tel: 01443 237 400
(Tecaform ad/Delrin acetal)

Falkiner Fine Papers Ltd
76 Southampton Row
London WC1B 4AR
Tel: 020 7831 1151
(paper, book-binding materials,
bone folders, books)

Glass Scribe
Spenser House
Caverfeidh Avenue
Dingwall
IV15 9TD
Tel: 01349 867088
(Image Pro film
and adhesive)

Graphics Art Equipment
11 Aintree Rd
Perrivale
Middlesex
UB6 7LE
Tel: 020 8997 8053
('Vegeol' for cleaning ink)

Chris Holliday
Modbury Engineering
311 Frederick Terrace
London E8 4EW
Tel: 020 7254 9980
(*press repair, transport and installation*)

Intaglio Printmakers
62 Southwark Bridge Rd
London SE1 0AS
Tel: 020 7928 2633/fax: 020 7928 27101
(*tools, inks, paper, presses, 'Quick Off'*
liquid transfer)

T.N. Lawrence & Son Ltd
(shop)117–119 Clerkenwell Rd
London EC1R 5BY
Tel: 020 7242 3534/fax:020 7430 2234

Mail Order : PO Box 3000, Lewes,
Sussex BN7 3DZ
Tel: 01273 488188/fax: 01273·483711
(*tools, inks, paper, books, wood blocks*
for engraving, presses, drying racks)

Lazertran Ltd UK
Ardwyn
Aberarth
Aberaeron
Ceredigion SA46 0LX
Tel: 01545 571149/fax: 01545 571187
e-mail: si@lazertran.demon.co.uk
(*transfer stencils*)

Nicoll Graphics
Unit 11–19
Thurrock Commercial Centre
Juliet Way, Purfleet Industrial Estate
South Ockendon
Romford
Essex RM15 4YG
Tel: 01708 867 382
(*'printight' photopolymer plates,*
metal plates)

John Purcell Paper
15 Rumsey Rd
London SW9 0TR
Tel: 020 7737 5199/fax: 020 7737 6765
(*paper stockists*)

Harry Rochat
15a Moxon St
Barnet
Herts
Tel: 020 8449 0023
(*intaglio, cylinder presses and plates*)

Rollaco
72 Thornfield Rd
Linthorpe
Middlesbrough
Cleveland TS5 5BY
Tel: 01642 813785
(*presses and rollers*)

Bob Stone and Michael Carlo
Tel: 01284 830595 or 01284 830456
(*'The Blueboy Press' relief press*)

Studio Tone Ltd
Blocking Die Specialists
6–8 Crown Close Business Centre
Crown Close
Wick Lane
Bow
London E3 2 JQ
Tel: 020 8980 4242/fax: 020 8981 2401
(*gold blocking and line engraving*)

Yorkshire Printmakers Ltd
26–28 Westfield Lane
Emley Moor
Huddersfield
W.Yorkshire HD8 9TD
Tel: 01924 840514
Fax: 01924 848982
(*tools, inks, paper, resingrave*)

NORTH AMERICA

**American Printing Equipment
Supply Co.**
42-25 9th St
Long Island City
NY 11101-491
Tel: +718 729 5779
(*general materials, letterpress equipment,*
lino, wood engraving blocks)

Dick Blick
PO Box 1267
Galesburg IL 61401
Tel: +309 343 6181
(general materials)

Sue Anne Bottomley
5246, Wildflower Terrace
Columbia
Maryland 21044
Tel: +410 740 3285
stenocut.tripod.com
(detailed guidelines on 'stenocut'
stencil printing)

Ralph Faust Inc.
542 South Ave East
Cranford
NJ 07016
Tel: +908 276 6555
(inks)

Graphic Chemical & Ink Co.
PO Box 27
728 North Vale Avenue
Villa Park
IL 60181
Tel: +708 832 6004
(inks and photopolymer (solar) plates)

Green Drop Ink Company
2 Cornhill Drive
Morriston
New Jersey 07960
Tel: +973 993 9764
Fax: +973 402 6070
(water-based inks)

The Japanese Paper Place
887 Queen Street West
Toronto
Ontario
Canada M6J IGS
Tel: +46 703 0089

Kate's Paperie
561 West 13th Street
New York
Tel: +212 633 0570

Lazertran Ltd USA
650, 8th Avenue
New Hyde Park
New York 11040
Tel: 1 800 295 7547
www.lazertran.com
(transfer stencils)

PhotoBrasive Systems
4832 Grand Avenue
Duluth, MN 55807
Tel: 1 800 643 1037
sandcarver@photobrasivessystems.com
(heliorelief photographic materials)

Paper Technologies Inc.
929 Calle Negocio
Unit D, San Clemente
CA 92673
Tel: +800 727 3716

Daniel Smith Inc
PO Box 84268
Seattle
WA 98124 9773
Tel: 1 800 426 6740
(general materials, inks, rollers, papers)

Sculptors' Supplies Co.
242 Elizabeth Street
New York
Tel: +212 334 3272
(wood carving tools)

Joe Spratt Woodworks
Box 158
Smithville
Ontario, CA LOR 2AO
Tel: +905 945 9621
Fax: +905 945 1054
(engraving blocks)

Takach Press Corporation
Shop: 2815 Broadway SE
Albuquerque
New Mexico, 87102
Tel: +505 242 7464
Fax: +505 888 6988
(presses)

Arjo Wiggins Speciality Papers
P.O. Box 220
21 Industrial Drive
South Hadley
MA 01075
Tel: +800 252 2211

Richard J. Woodman
3558 Jefferson Ave
Redwood City
California 94062
Tel: +415 369 5759
(Resingrave)

Zellerbach Paper Co.
245 South Spruce Avenue
South San Francisco
Tel: +650 589 5577

AUSTRALIA

Art Papers
243 Stirling Highway
Claremont
Western Australia 6010
Tel: +618 9384 6035

Artequip
Factory 5
18 Powlett St, Moorabin
Vic 3189
Tel: +613 9555 8644/fax: +613 9555 9052
(Relief and etching presses)

enjay
Tel: +613 9699 9282
(intaglio presses)

Expressions Art
PO Box 2095
Kew, Vic 3101
Tel/fax: +613 9853 6435
(paper)

Jacksons
103 Rokeby Road
Perth
Tel: +618 9381 2488
(fine art and etching supplies)

Melbourne Etching Supplies
44–46 Greeves St (shop)
33 St David St (factory)
Fitzroy, Vic 3065
Tel: +613 9419 5666/fax: +613 9419 6292
(tools, inks, paper, presses, photopolymer plates, studios with relief printmaking facilities)

The Student Supply Shop
Old College of Art
Cnr Foxton Street and Clearview Terrace
Morningside
Brisbane
Queensland 4170
Tel: +617 3399 3363
(paper and printmaking supplies)

EUROPE

Bendini Torchi Calcografici
e-mail: torchio @hotmail.com
Tel/fax: + 39(0) 51 619 4520
(presses)

PhotoBrasive Systems Europe
Saverne
France
Tel: +33 3887/2929 fax: 33 3887/08z28
(heliorelief photographic materials)

The Printmakers Experimentarium
Trepkasgade 8
DK-2100 Copenhagen
Tel: +45 35 35 39 07
(printmaking equipment and supplies)

Sebino Colori
Via Farini, n. 21/E
40124 Bologna
Italy
Tel: +39 051 22 25 90
(inks and general printmaking supplies)

TofKo Norremarksvej 27
P.O. Box 101
Klarup DK-9270
Tel: +45 9831 7711
(presses)

STUDIOS & WORKSHOPS

UK

Artichoke Workshop
Unit S1
Shakespeare Business Centre
245a Coldharbour Lane
London SW9 8RR
Tel: 020 7924 0600

Belfast Print Workshop
186 Stranmillis Rd
Belfast N1 BT9
Tel: 01232 381591

Edinburgh Printmakers Workshop
23 Union Street
Edinburgh EH1 3LR
Scotland
Tel: 0131 557 2479
Fax: 0131 558 8418

Gainsborough Print Workshop
Gainsborough Street
Sudbury
Suffolk CO10 6EU
Tel: 01787 372958

Glasgow Print Studio
22 King Street
Glasgow G1 5PQ
Scotland
Tel: 0141 552 0704
Fax: 0141 552 2919

Halfmoon Printmakers
Farland Studio
127a Half Moon Lane
London SE24 9LH
Tel: 020 7274 1612

Linda Richardson
1 Styles
Little Bardfield
Braintree
Essex CM7 4TP
Tel:/fax: 01371 810769
e-mail: lind1art@callnet0800.com

London Print Workshop
421 Harrow Rd
London W10 4RD
Tel: 020 8969 3247

Spike Island Printmakers
Spike Island
133 Cumberland Rd
Bristol BS1 6UG
Tel: 0117 929 0135
Fax: 0117 924 9167

NORTH AMERICA

Below the Surface Printmaker's Atelier
27 North 4th St, Minneapolis
Minnesota 55401
Tel: +612 340 1001

Creative Capital
65 Bleeker Street
7th Floor
New York
NY 10012
Tel: +212 598 9900/f: +212 598 4934

Galamander Press
526 West 26th St, zip 816
New York, NY 1001
Tel: +212 255 3094

The Graphic Art Studio
2565 3rd St, 305
San Francisco
CA 94107
Tel: +415 285 5660

Graphicstudio/USF
3702 Spectrum Boulevard
Suite 100
Tampa
Florida 33612
Tel: +813 974 3503/fax: +813 974 2579
e-mail: gsoffice@arts.usf.edu

Lower East Side Printshop
59-61 East 4th Street
6th Floor
New York
NY 10003
Tel: +212 673 5390

Sev Shoon Arts Center
5200 Ballard Ave
N.W. Seattle
WA 98107
Tel: +206 782 2415

Split Rock Arts Program
University of Minnesota
150 Wesbrook Hall
77 Pleasant Street
S. E. Minneapolis
MN 55455
Tel: + 612 624 4000

The Rutgers Centre for Innovative Print and Paper
Mason Gross School of the Arts
33 Livingstone Avenue
New Brunswick NJ 08901
Tel: +732 932 2222, ext 838

EUROPE

Atelier Nord
Negregate 8 – N-0551
Oslo
Norway
Tel: +47 22 70 49 90

DIT School of Art and Design
Mountjoy Square
Dublin 1
Ireland
Tel: +1 402 4138
Fax: +1 402 4297

Il Bisonte
Via San Niccolo 24/r
Florence
Italy
Tel: +39 055 234 2585

The Printmakers Experimentarium
Trepkasgade 8
DK-2100 Copenhagen
Denmark
Tel: +45 35 35 39 07

Santa Reparata Graphic Art Centre
Via Santa Reparata 41
50129 Florence
Italy
Tel: +055 214 365

Scuola Internazionale di Grafica Venezia
Santa Croce 2213
30135 Venice
Italy
Tel: +39 041 721 950
Fax: +39 041 524 2374

AUSTRALIA

Australian Printmakers Network
68 Oxford St
Darlinghurst
NSW 2010
Tel: +612 9332 1722

Australian Print Workshop
210 Gertrude St
Fitzroy
Victoria 3065
Tel: +613 9419 5466/fax: 613 9417 5325

Edith Cowan University
2 Bradford Street
Mount Lawley 6050
Australia
Tel: +608 937 06239

Red Hands Prints
1669 Coonawarra Rd
PO Box 36208, Winnellie
Darwin, NT
Tel: +618 9847 0720

Studio One
PO Box 164
Kingston, ACT 2604
Tel/fax: +616 295 2781

SOCIETIES

UK

Greenwich Printmakers
1A The Market
Greenwich
London SE10 9LZ
Tel: 020 8858 1569

The Printmakers Council
Clerkenwell Workshops
31 Clerkenwell Close
London EC1 0AT
Tel: 020 7250 1927

Royal Society of Painter Printmakers
Bankside Gallery
48 Hopton St
London SE1 9JH
Tel: 020 7928 7521

The Society of Wood Engravers
North Lodge
Hamstead Marshall
Newbury
Berkshire RG20 0JD
Tel: 01635 524 255

NORTH AMERICA

The American Print Alliance
302 Larkspur Turn
Peachtree City
GA 30269 2210

http://thewww.com/printalliance

The alliance represents over 3,000
artists who are members of ten councils
including:
The North West Print Council, The Mid
America Print Council, The Florida
Printmakers Society, Honolulu
Printmakers, Conseil Quebecois de
l'estampe and The California Society of
Printmakers.

American Institute of Graphic Artists (AIGA)
PO Box 790
Raleigh
N. Carolina 27602–0790

Association Presse Papier Inc.
73 Rue St Antoine
Trois-Rivieres
(QC) G9A 2J2
Tel: +819 373 1980

Los Angeles Printmaking Society
Lankershim Arts Center
5108 Lankershim Boulevard
North Hollywood 91601
LAPS@art2u.com

The Society of American Graphic Artists (SAGA)
Room 1214
32 Union St
New York
NY10003

AUSTRALIA

The Print Council of Australia Inc.
459 Swanston St
Melbourne
Vic 3000
Tel: +613 9639 2463/fax: 613 9663 2331
(visual arts organisation promoting contemporary printmaking)

'*My Father's Dreaming' by Kevin Gilbert, Aus, linocut.*
Indigenous Australian, statesman, poet, playwright, author and artist,
Kevin Gilbert died in 1993. His 1960s linocuts are interpreted as the
beginnings of indigenous Australian printmaking. Kevin carved his first
linocuts in prison using old lino from the prison floor and tools made
from a spoon, gem blades and nails.
'I wanted to show the natural pride of the Aboriginal artist,
the cave, the art, the landscape.'

INDEX